BUST TO BOOM Documentary Photographs of Kansas, 1936–1949

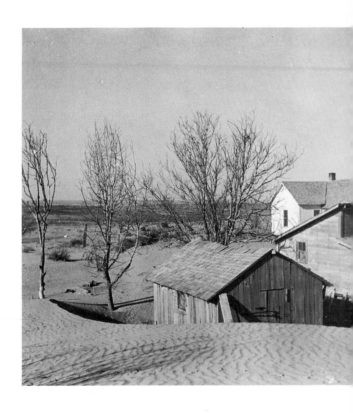

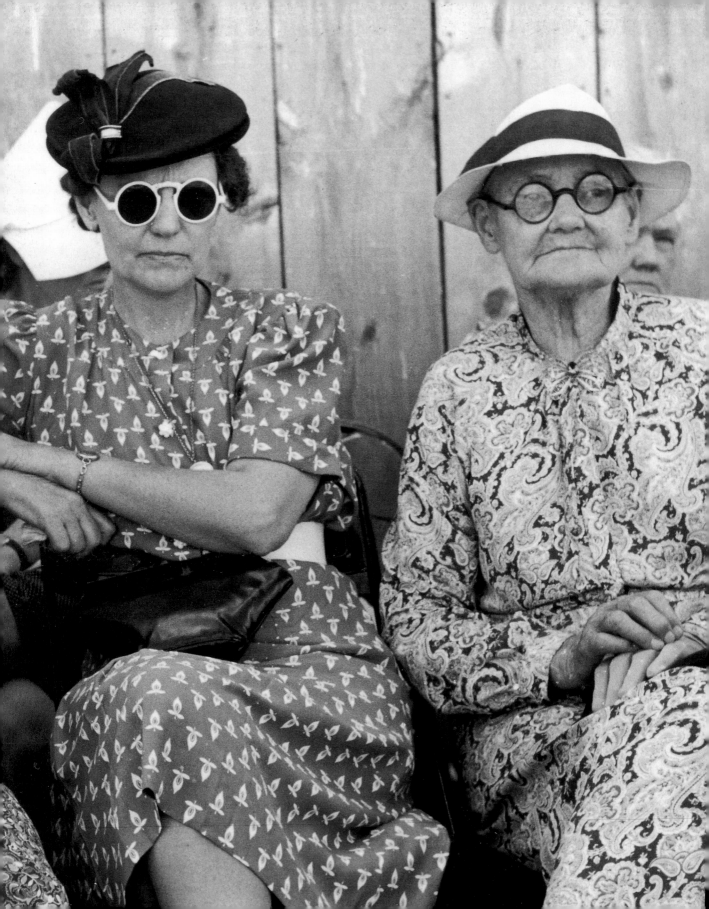

DOCUMENTARY PHOTOGRAPHS OF KANSAS, 1936–1949

Bust to Boom

EDITED BY Constance B. Schulz

TEXT COMMENTARY BY Donald Worster

UNIVERSITY PRESS OF KANSAS

© 1996 by the
University Press of Kansas
All rights reserved

Published by the
University Press of Kansas
(Lawrence, Kansas 66049),
which was organized by the
Kansas Board of Regents and
is operated and funded by
Emporia State University,
Fort Hays State University,
Kansas State University,
Pittsburg State University,
the University of Kansas, and
Wichita State University

Library of Congress Cataloging-in-Publication Data
Bust to boom : documentary photographs of Kansas, 1936–1949 /
edited by Constance B. Schulz ; introduction by Donald Worster.
p. cm.
ISBN 0-7006-0799-4 (alk. paper)
1. Kansas—social life and customs—pictorial works.
2. Kansas—social conditions—Pictorial works.
3. Depressions—1929—Kansas—Pictorial woks.
4. Documentary photographs—Kansas.
I. Schulz, Constance B.
F682.B87 1996
978.1—dc20 96-23859
British Library Cataloguing in Publication Data is available.

Printed in the United States of America

Designed by Richard Hendel

10 9 8 7 6 5 4 3 2 1

The paper used in this publication meets the minimum
requirements of the American National Standard for Permanence
of Paper for Printed Library Materials z39.48-1984.

CONTENTS

PREFACE

It is fitting that the photographic legacy of Roy Emerson Stryker, a son of Kansas, should at last find an audience in the state of his birth. Stryker directed the three projects that hired dozens of photographers to create a record "for the files" of the Farm Security Administration (FSA), the Office of War Information (OWI), and Standard Oil of New Jersey (SONJ). The more than 200,000 images produced in the 1930s and 1940s by the forty-four FSA/OWI and thirty SONJ photographers document the lives of ordinary Americans going about their daily business in the face of the extraordinary circumstances of depression, war, and postwar economic recovery. Collectively, they have shaped our visual memories of that time.

FSA/OWI and SONJ photographers made ten known brief trips into Kansas between 1936 and 1949, leaving a legacy of more than 800 photographs in collections now housed in the Library of Congress Prints and Photographs Division and the Special Collections of the Ekstrom Library at the University of Louisville. Of the six FSA/OWI photographers who traveled into or through Kansas, five—Arthur Rothstein, John Vachon, Russell Lee, Marion Post Wolcott, and Jack Delano—are well represented by their photographs in this book. Kansas photographs by three photographers Stryker hired while at SONJ—Edwin and Louise Rosskam and Charles Rotkin—bring the book to its conclusion.

Most other state-oriented photographic publications that have drawn from the FSA/OWI images have ended their coverage with 1942, when Stryker transferred the agency's photographs to the Library of Congress. The particular contribution of this book is that it recognizes that Stryker's work in documentary photography did not end with his leaving federal government service, but continued for another decade at SONJ. In *Bust to Boom*, that photographic legacy is accorded a recognition and inclusion comparable to that usually reserved in state studies only for Stryker's earlier projects.

Because of the nature of all three projects—of the FSA, to capture on film the impact of federal programs on rural poverty; of the OWI, to record a nation preparing successfully to fight a war; of SONJ, to document the impact of oil production and consumption on the United States—the coverage that Stryker's photographers gave to Kansas is neither systematic nor representative. That limitation is reflected in

the images selected for this volume. There are relatively few photographs of the state's largest cities and towns, and none at all of its colleges and universities.

Recognizing these omissions, this collection of images nevertheless represents an important contribution to Kansas and an understanding of its history. Despite the wide publication of FSA photographs during the late 1930s and the 1940s, the extensive use of the Library of Congress holdings in exhibits and books during the decades since, and recent renewed interest in the SONJ photographs, very few of the striking images of Kansas and Kansans that are reproduced in this volume have been selected previously for publication or exhibition.

Bust to Boom and the related exhibition in the fall of 1996 by the Kansas Historical Society of many of its prints are intended to redress that omission. Kansans, and Americans everywhere, are invited to see through these fresh images a not-so-distant past, a Kansas that endured years of dust bowl "bust" to emerge into the economic "boom" of the postwar years.

ACKNOWLEDGMENTS

Without the cheerful help of Toni Smart and Victoria Kalemaris, graduate assistants at the University of South Carolina, much of the labor of choosing and preparing for publication the photographs in this volume would have been much more difficult.

The generous support and encouragement of the staff at the Prints and Photographs Division of the Library of Congress, and of James C. Anderson in the Special Collections Division, Ekstrom Library, University of Louisville, made the process of preparing a book based on the photographs in their collections a joy.

Michael Grant, a doctoral candidate at the University of Kansas, provided valuable research help on the text commentary.

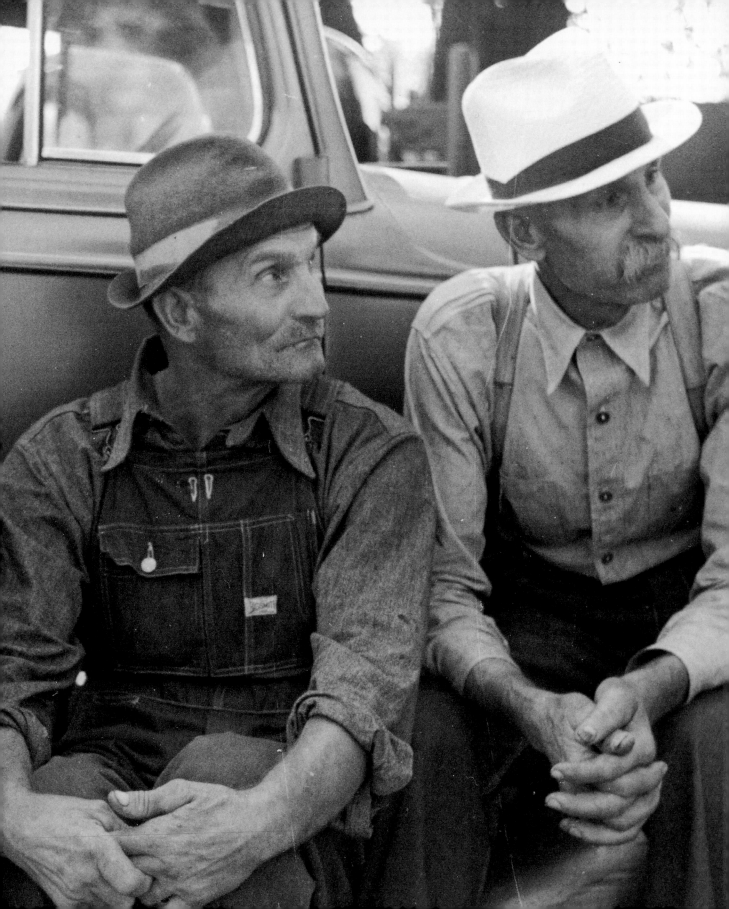

TEXT COMMENTARY Donald Worster

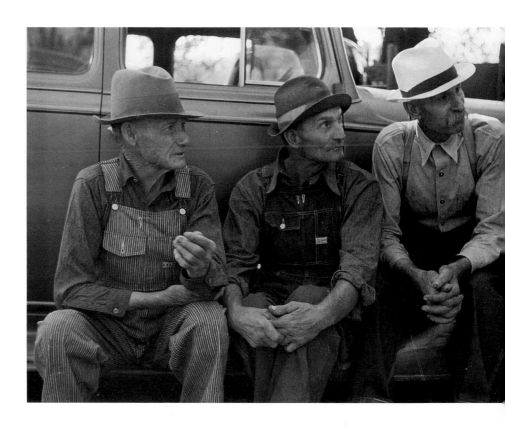

The faces in this book are those of our parents or grandparents a half century ago. That is less than a single human lifetime, yet it can seem very far away, so much has changed since then. Sitting in their bold print frocks or lined up with all the children in front, they look at us today with a smile or a frown, sometimes having fun, sometimes riven with anxiety, as from an old family photo album. They do, that is, if your family was in those years living a poor, rural, or working-class life; none of the country-club set can be found here. These are the ordinary people of Kansas going through a hard patch of war, dust storms, and depression, trying to survive. If we want to understand what they and their times were like, then we need to scrutinize their pictures carefully.

Evidently life was a lot cheaper fifty or sixty years ago. Six gallons of gasoline sold for only a dollar. A box of Cracker Jack cost 3 cents. A bottle of ice-cold soda pop was a nickel, as was a twelve-ounce glass of beer. But you couldn't legally buy liquor

at any price during this period; Kansas was the driest state in the nation and kept whiskey off the shelves until after the Second World War. You could, however, get a hotel room for 50 cents, as one of the photos here reminds us, if you didn't mind sleeping with cowboys near the stockyards. You could buy an average house for $3,000, or if you were a typical renter, you paid a mere $20 a month.

A cheap way to live. Was it also a simpler, less pretentious, more honest life? The Kansas of those days, nostalgia tells us, offered a quieter existence, free of the greed and violence of our own time, rich in friendly neighbors—a place where you could still find old-fashioned virtue and trust a man to do what he said he would do. There is much in these photos to suggest that such a kindly world did exist once upon a time: when 4-H Club fairs and pie-eating contests were high entertainment, when lunch pails were packed with homemade food, when families stood firmly together. But we should remember that those cheap prices meant low incomes, which brought their own kind of degradation.

This was a time of widespread poverty. The people in the photos drove shabby cars; wore drab, frayed clothes; and sat in plain wooden chairs. Many went about in bare feet. They used outdoor privies. They covered their walls with newspapers to keep out the cold. The chief reason for those conditions was the low rewards they got for their labor. In the early 1930s, the price of wheat fell to 33 cents a bushel; corn, to 15 cents; hogs, to 3 cents a pound; beef cattle, to 4 cents. Wages and salaries were just as bad. Schoolteachers, most of them women, fared poorly in those years, earning less than $100 a month, in some places as little as $1 a day. In 1936 the State Superintendent of Schools announced that over 400 schools had to close their doors by March; they were out of money. When the earliest of these photos was taken, Kansans were still suffering through the worst economic depression in our history, and it would not be over for another five or six years.

Depression was not where the forward march of civilization on the Great Plains was supposed to end. Before the 1930s, Kansans had assumed that they were approaching the promised land, after a long passage through hardship and difficulty, and soon they would be enjoying a universal, permanent prosperity.

During the nineteenth century, Kansas had suffered an image as a wild, rough, fanatical place. The state had started off with a bloody struggle between the forces of slavery and freedom, which the latter narrowly won. Then the free, overwhelmingly white pioneers had encountered a defensive Indian population, who fiercely attacked their wagons and homesteads, requiring the protection of the U.S. cavalry. Then had

come even more dangers and bloodshed: the depredations of native fauna, including plagues of grasshoppers that ate crops out of the ground; the noise and tumult of cattle drives; the antics of hard-drinking drovers; the ruthless order dictated by badge-wearing gunslingers; the angry Populist uprising against an indifferent Wall Street. Reality in nineteenth-century Kansas may have been more tame than those images suggest; nonetheless, by the turn of the century people longed for a more peaceful domesticity in which they could improve their lot by steady work, earning a fair return, bringing them the long-delayed comforts of civilization.

By the early twentieth century, Kansans had succeeded in overcoming their wild image. Where there had once been a forlorn, sun-baked, treeless prairie, they declared, was now a green, productive farmland, dotted with thriving little towns, watered by abundant streams. A place where men who had once eaten buffalo tongues or parlayed with Chief Satanta could now sit quietly rocking on their front porches. Where women of strong backs and courageous hearts could now in their golden years tend their gardens.

One prominent symbol of that postfrontier Kansas of peace and plenty was the newspaper editor William Allen White and his hometown of Emporia. During the first four decades of this century, both man and town came to be seen across the nation as Kansas at its idyllic best—small, cheerful, morally upright. White himself claimed that Kansas was the true heir to the old New England Puritan tradition in which piety and commerce worked together for the common good. The hard, tumultuous, hot-eyed past had been left behind. In its place was emerging a state inhabited by Methodists and Republicans, level-headed, moderately conservative in social attitudes but highly progressive in business and orderly in all their habits.

Not everyone liked the new Kansas. Among cynical Greenwich Village artists and little-magazine intellectuals, the state had a far less flattering reputation as a place of stultifying complacency and smugness. Its happy boosters seemed too uncritical of their bourgeois values, too content with their cultural mediocrity, complained the critics. Money had come to dominate personal values, said a native daughter, Meridel Lesueur: "[T]he rigors of conquest have made us spiritually insulated against human values." She worried whether her people had "only money dreams, power dreams."* Heywood Broun, an eastern journalist, found Kansas in 1931 to be "a place devoid of beauty, where existence is an endless and deadly monotony."†

Whatever the truth of such criticism, postfrontier Kansans shrugged it away and continued to hold their state up as the best that America had to offer. Crops were

*Meridel Lesueur, "Corn Village," *Scribner's Magazine,* August 1931, 134, 135. †Heywood Broun, quoted in Robert Bader Smith, *Hayseeds, Moralizers, and Methodists: The Twentieth-Century Image of Kansas* (Lawrence: University Press of Kansas, 1988), 78.

good; towns were growing; the trains ran on time. White wrote of his home county that it was inhabited by

> a prosperous people, burdened neither by an idle and luxurious class who are rich, nor taxed to support a sodden and footless class verging upon pauperism. A sober people practically without a criminal class, an intelligent people in so far as intelligence covers a knowledge of getting an honest living, saving an occasional penny, and living in a rather high degree of common comfort; a moral people in so far as morals consist in obedience to the legally expressed will of the majority with no very great patience for the vagaries of protesting minorities. A just and righteous people in so far as justice concerns the equitable distribution of material things, and righteousness requires men to live at peace among men of goodwill.[*]

[*]William Allen White, "Kansas: A Puritan Survival," *The Nation,* April 19, 1922, 462.

The praise here was edged with caution (in a couple of years White would have to take on the state's Ku Klux Klan for its intolerance toward minorities), and he gave the highbrow critics this much: "What we lack most keenly is a sense of beauty and the love of it." But otherwise Kansas was, in his opinion, a good place to live and was getting better all the time, if it could continue to keep the old anarchic devils tied down.

Less than a decade later, William Allen White, the state of Kansas, and indeed the whole country were rudely shaken by disaster. The march of progress came crashing to a stop. The quest for stable prosperity faltered. Dreams came apart. Well-worn habits of thought no longer seemed effective. We can see that in people's faces in this book, for they are often worried, pensive, and uncertain of the future. They seem to find enjoyment in their bleak surroundings, but they do not look quite like the masters of a continent, or even the masters of their own private fate.

Consider the story of one young couple of that time who are not pictured here, whose names have been changed, but who were real and typical Kansans. Call the man Walter and his wife, Vada. They had been born immediately after the First World War in a western county to poor tenant farmers, renting small parcels of land from more successful men. In 1930, nearly half of the state's farmers were tenants like them. Some were black, but most were white; indeed, in this particular case, the parents were all native-born, Anglo-Saxon, church-going Protestants.

In 1936, Walter and Vada were still in high school, courting and dreaming of a life together, although only Walter would earn a diploma. Soon after marriage, despair-

ing of finding their own productive farm in a dust-ravaged countryside, they determined to go west to find better opportunity. They bought a very used Ford. Along with thousands of other poor folks, they drove all the way to California's deserts and valleys, passing through Colorado, New Mexico, and Arizona; grabbing odd jobs along the way; hoping vainly for a new life at each stop. Two babies were born out there in a small hot Mohave railroad town, where at last Walter found good work as a switchman. Then the Second World War erupted, pulling the little bit of hard-won stability from under their feet. Walter volunteered to join the Marines and was sent to the Pacific islands, where for the next four years he lived with other nervous men in the holds of ships or in makeshift barracks, fought on coral beaches under rustling coconut palms, fought at Guadalcanal, fought all the way to Iwo Jima, and was in on the occupation of Japan. Vada, meanwhile, had no choice but to return to her parents' town in Kansas, where she found work in a smelly defense plant, turning eggs into powder for the troops overseas. When the war was over, Walter trudged back to Kansas too, and both of them, with a growing family to support, still could not see very far ahead or know what to do next. So far in their lives they had eked out only a bare survival. They had shared in a smashing victory over distant enemies, but still they had secured no comfortable future at home.

The constant refrain in their story had been upheaval and separation. To begin with, they had lost their place in an older rural community, moving away from their supporting network of family and friends. All on their own, they had tried desperately to find a niche in the American industrial order thousands of miles from home. Then they had lost each other's company for a long stretch of years, with only an occasional letter to and from the battle scene. That was not the whole of it, either: powerful new technologies had come hurtling down on them one after another in those years and after, radically altering their daily existence—radio, television, medicines, automobiles, gasoline tractors, paved highways, air travel, the atomic bomb.

Of course, their parents' generation had gone through plenty of big changes too. They had moved into Kansas in the late nineteenth century from Iowa and Illinois, leaving many relatives behind. They had had to depend heavily on the distant metropolitan economies of Kansas City, Chicago, and New York, raising wheat to sell in a competitive market, shipping it by rail to the big mills. They had perused mail-order catalogues offering the newest gadgets and fashions. All the same, most of their days must have seemed far removed from outside social forces—away from, if not wholly independent of, the industrial life. At night they had listened to the silence of the

High Plains rather than to a radio, and all through the year the wind had been their closest companion. Wherever the trains did not reach, which was most of the country, they had gone slowly on foot or by wagon. They had raised nearly all their food, from meat to potatoes. Sweating so hard over their farms, what did they know of foreign parts? The local paper may have told them of a few major events occurring in the outside world, a bizarre suicide in Paris, a colonial war in Africa; but what did such places really mean to them? What did they know, what could they have known, of the South Pacific or Japan, or even of Germany or England?

With the generation of Walter and Vada, however, that old surviving quality of rural isolation, of semi-independence, ended, never to be restored. Suddenly, Kansans' lives did not seem to be their own any more or under their control. They were pitched to and fro by far-flung, invisible powers and events.

Walter and Vada did survive, but the cultural earthquake of the period 1936 to 1945 left them, as it did others, with many hidden injuries. They harbored a few gnawing resentments, among them the feeling that they had had to pay the full harsh price of living in this new age, not asking for much, enduring a lot, while others had not paid their share. Those who had it easiest in the Depression were the idle rich, while in the postwar years it became the "undeserving poor," many of them racial minorities, who had an easier ride. Why, these Kansans wondered ever after, shouldn't every American have to put up uncomplainingly with hard times and work out his or her own salvation?

The photographers represented in this book did not take Walter and Vada's picture, but they took pictures of hundreds of other Kansans, recording both their successes and their failures in dramatic black-and-white tones. All the photographers were outsiders sent to Kansas on special assignment from Washington, as they were sent all over the country. Their employer was the Resettlement Administration, established in 1935, and its successor, the Farm Security Administration, which came along two years later. Both were federal agencies set up to help poor, marginal farm families survive the Great Depression and get a more secure hold. The RA planned to move many families away from places like the droughty plains to better watered lands where they could raise a good crop, sometimes in a cooperative-ownership arrangement. The FSA abandoned that scheme, which was very unpopular, but continued to work with hundreds of thousands of families across the nation to lift them out of poverty. Both agencies provided long-term, low-cost loans to risky cases the banks would not touch; they worked out individual farm plans (detailing which

crops should be planted where and when, what machines should be purchased, what diversification was needed); they showed wives how to budget their household funds; and they gave instructions on nutrition and health care. The mission of the photographers was to show how rehabilitation clients lived. They documented how clients were making improvements and, with federal help, solving their problems. But in the course of their assignments, the photographers also tried to capture a broader American life going through massive change. Looking back on their achievement, Edward Steichen called the collective, nationwide artistry of these men and women "a series of the most remarkable human documents ever rendered in pictures."*

Such picture taking, no matter how sensitive or brilliant, could not reveal the full depth of a whole generation's lives and thoughts. The photos included here were the product of only a few months of traveling through a state of 82,000 square miles and through a full decade of its history. They do manage, nonetheless, to provide valuable glimpses into the complicated social and environmental texture of that time: the look of stores and locomotive-repair shops, of farmhouse interiors, of urban street scenes, of the broad Kansas sky and land. They give us glimpses of the manner in which people, especially rural people, once lived and prepared for global war.

The census data of the United States, taken every ten years, can supplement these photographs usefully.† In the 1930 census, Kansas counted a population of 1.9 million. The state's growth had slowed considerably since the heady years that followed the Civil War, when Kansas was, if only briefly, the fastest growing state in the union, and it would slow even more in the years ahead. The vast majority of its people—over 95 percent, in fact—were white and native born, mostly of midwestern origin. A small part of the white population was European born, the largest numbers coming from Germany, Russia, and Sweden to settle on prairie farms, although their numbers had dwindled from an earlier peak of immigration. Many of the newer foreign born came from Mexico—escaping the turmoil of the Mexican Revolution, which broke out in 1910 and introduced a long unsettled period. The Mexican migrants provided inexpensive labor for agriculture, mining, and above all the railroads. Most of them had moved into *colonias* or *barrios* along the train tracks or near meat-packing plants, where they lived segregated from the Anglo population. African-Americans numbered 66,000 in 1930, a hundred times more numerous than they had been right after the Civil War; some of them had been homesteaders, but by now most lived in town and were also set apart and ignored. Then there were nineteen residents of Japanese ancestry, ten of them foreign born—a tiny group

*Edward Steichen, quoted in Hank O'Neal, *A Vision Shared: A Classic Portrait of America and Its People, 1935–1943* (New York: St. Martin's Press, 1976), 305.

†I have drawn extensively in this Introduction on the Fifteenth Census of the United States (1930) and the Sixteenth Census of the United States (1940), both the general state figures and topical tables; and the United States Census of Agriculture (1935 and 1945), all published by the Government Printing Office in Washington, D.C.

whose lives would be more drastically affected by coming events than perhaps those of any other Kansans.

Farmers were, ironically in a heavily agricultural state, another demographic minority. Slightly less than a third of the state's families lived on farms in 1930, and that percentage was becoming smaller and smaller with mechanization. The census counted 166,000 farms, covering 47 million acres—more acres than any state except Texas. Half of those acres were planted to crops; the rest were in pasture or fallow. The average size of a cash-grain farm in 1930 was 386 acres; of a stock ranch, 1,650 acres.

Although lagging behind national trends, Kansas was gradually moving away from its roots in the country and toward a more urban way of life. In 1930 Kansas City, with a population of 122,000 (not counting the larger Missouri portion of that city), ranked as the state's leading metropolis, the economic hub for a vast hinterland, a great regional center for stockyards, flour mills, manufacturers, and retailers. Closely following in numbers was Wichita, once a ragged little cattle-shipping town, now more than 100,000 strong too and increasing fast. In third place was the capital city of Topeka, with its handful of state office buildings. The largest settlement in the western third of the state was Dodge City, another old cow town, with 10,000 inhabitants. A city of that size or larger was rare everywhere in the state; there were only twenty of them altogether. The typical Kansan, therefore, lived in a small market center of fewer than 5,000 people, surrounded by farms and farmers, ranches and ranchers. One did not have to look far beyond the edges of such places to see soil, grass, wheat, corn, cattle, sheep, pigs. Nonetheless, one lived at some cultural distance from the land amid brick streets and electric lights, small grocers and dress shops, automobile dealers and drug stores, all within easy walking distance.

As a farmer from Stafford County, Erich Fruehauf, reminds us, the gap between rural and urban life was once much greater than it is today, almost marking off different societies:

Today it is hard to believe, and should be recalled more often, that up to about 1940 there was such a difference in the life style between city and country, that the city cousin looked down with pity on the farmer as a hayseed or country hick, in short, as a second class citizen because he lacked the comforts of the city. He had no electricity, and for this reason only kerosene or gasoline light, no running water, no refrigeration, no electric washing machine, water heater, range, no indoor

bath and toilet facilities, not even a simple fan, not to mention air conditioning. He still bought ice for an inefficient icebox in the kitchen, and fiddled with a battery-operated radio set. All these niceties of city life were known, of course, but unobtainable to the farmer because nobody furnished electric energy in the open country, away from the cities and towns.[*]

*Erich Fruehauf, "Fifty Years on a One-Family Farm in Central Kansas," *Kansas History* 2 (Winter 1979): 258.

That was the Kansas of the 1930s. By the census of 1940, both town and countryside had experienced significant movements of population. For the first time in its history, Kansas had lost population—lost more than any other state in the country. The intervening years had seen a net decline of 80,000 inhabitants statewide.

Most of that loss came from scattered farmsteads emptying at a discouraging rate. The rural–farm sector showed a decline of 14 percent over the decade, while the urban population actually increased. In many rural high schools, half of the graduates chose to leave the state altogether, as Walter and Vada did. By the end of the 1930s, the median age of citizens was several years older because so many young people had left out of desperation. Out-migration was especially heavy from 1935 on, following a series of bad crop years. The majority of out-migrants went far away from Kansas, skipping over the adjoining states of Colorado and Missouri, some going all the way to the west coast or Chicago. They included 44,000 farmers, farm laborers, and farm managers, along with thousands of clerks, salespeople, industrial operatives, craftsmen, housewives, and foremen.

There were three major forces—agents of dislocation—driving those folks from their homes and families or otherwise disturbing their lives in this period. None was exactly new to the state or nation, but now they became more intensely active than ever before, and they occurred simultaneously in a short span of time, leaving a complicated impact.

First, there was the unsettling hand of nature. This was an old and familiar enemy to a farming population, but the struggle with nature took a darker turn in the 1930s. Kansans became victims of the most severe drought in more than a century. The state's normal average rainfall is more than thirty inches, but the extreme western part gets only fifteen inches, not enough for steady cropping year in and year out; worse, beginning in 1931, rainfall averaged far less than that. East and west alike became unusually hot in the summers (records of over 120 degrees were set in July 1936) and abnormally dry throughout the year. By decade's end, Ellis County, for example, was a full two years behind in its customary supply of moisture.

Agricultural catastrophe followed that unsparing desiccation. Winter wheat, which is planted in the fall, withered on the stalk by early spring; the corn turned brown and rattling by August; and even the native grasses crackled underfoot. As crops failed, much of the plowed surface of the state lay without protective cover from the potent winds. The winds began to agitate the dry, bare soil, sending it flying to the next farm, the next county, the next state, even as far away as the Atlantic Ocean. None of the photographers in this book managed to record one of those terrible dust storms, but others did; their images, examined years later, can still stun the mind. Dark, silent dust storms came suddenly on the horizon—"boogery" as the locals said. The worst of them lifted topsoil more than a mile high, and blew it faster than a car could go. Dust blasted and engulfed whatever was in its path. It drifted around houses, piling up as high as the eaves, covering the windows like windswept snow. It collected around tumbleweeds caught in barbed-wire fences, until the fences disappeared. It seeped into the lungs of living creatures, from jackrabbits to humans, suffocating them or sapping their vitality. It whistled through cracks in the walls, coated pillows, blackened tableware, hung in the air for hours, days, even weeks. At times, the sun was blotted out completely, noontime rapidly turning to night. The worst period for what came to be called the dust bowl was from 1933 to 1940, when the plains averaged over forty major storms a year.

The whole region, from Texas to Canada, once touted as the breadbasket of the world, now ranked as an ecological disaster, and many of the out-migrants were what we would now call "ecological refugees," fleeing a degraded environment. Their calamity set Kansas and other plains states apart from the rest of the nation as a place to avoid and yet became a metaphor of national failure.

We have often explained this disaster as the work of nature or an act of God, and to some extent it was. But to leave it at that explanation would be far too simple. The causes of the dust bowl were partly an adverse turn in the climate and partly an irresponsible agricultural expansion that had outrun common sense. The ground, in other words, was virtually prepared to blow—prepared by several years of overconfident farming. Owners and renters of land alike had invested in the newest farm equipment, expanded their operations to make full use of combines and tractors, borrowed heavily at the banks to pay for it all, and, most seriously, made a dangerous assumption that nature would always cooperate with their ambitions. Many saw a big wheat crop as a way to get rich quickly, to pay off their creditors, or to acquire still more land. Some tried to blame such a high-risk strategy on the federal govern-

ment, which during the First World War had urged the plains farmer to plant more wheat. But a major expansion of wheat cultivation occurred a full ten years after the war was over, in the late 1920s. Finney County, for instance, increased its wheat acreage from 69,000 acres in 1927 to 222,000 in 1931—and increased its harvest from fewer than 300,000 bushels to nearly 5 million. The congressman from that western district, Clifford Hope, Sr., summed up what had gone wrong: "A sort of madness pervaded the atmosphere and I fell for it just like everyone else. I bragged about that crop [of 1931] to everyone who would listen, in Washington and elsewhere. But viewed in the light of what has happened since, this big crop was more of a disaster than anything else."*

The disaster was both economic and environmental. First, the great plow-up meant, at least for a while, as long as the rains continued, a terrific overproduction of wheat, which in turn meant plummeting prices. The more farmers produced, the lower the prices for their crops fell, and the more they felt compelled to produce. In the second place, the plow-up left a vast region of the state extremely vulnerable to drought, which is, after all, an inevitable part of the Kansas environment. Put it all together, then—an overinvestment of capital, a race to make money, a disregard for natural limits, along with the drought—and you have a catastrophe affecting not only thousands of farmers, but all those in town and city dependent on their well-being.

Among those shaken by the farm debacle were many local units of government. They depended almost exclusively on the property tax, but in the 1930s they often could not collect it, and in some cases could not, or did not, for a whole decade. Some farms were simply abandoned to the wind. Others had to be auctioned to pay the bills. Tax delinquency reached crisis levels. Early in the decade, when the debt load–low price squeeze became severe, the Farm Bureau, a private lobbying organization of the more commercially successful operators, persuaded legislators to establish a statewide progressive income tax to lessen pressure on rural property owners; however, the rates were never set high enough to bring in sufficient substitute revenue or to relieve local shortfalls. Counties had to cut back their services. By 1940, some dust bowl counties had lost as much as 25 or 30 percent of their population, and Morton County had lost nearly 50 percent.

We should not single out the farmers (not even the notorious "sidewalk" or "suitcase" farmers, who did not live on the land but came from a nearby town or distant city to speculate in wheat) as peculiarly shortsighted or destructive. They were only a

*Clifford Hope, Sr., "Kansas in the 1930's," *Kansas Historical Quarterly* 36 (Spring 1970): 3.

small part of a national economic culture that failed everywhere—in real estate, in manufacturing, in the stock market. Americans across the whole private sector had played a risky game, endangering their country's welfare and institutions. Neither should we blame the "dirty thirties" simply on nature, for here, as elsewhere, nature had already become incorporated into an economic system, and it was difficult to say precisely what was nature's and what was man's fault.

The second agent of dislocation was the American businessman, embodying the entrepreneurial spirit of capital. That is too simply put, of course; like the farmer, the individual businessman was often a mere cog in the vast, complex machinery of industrial production, regulated almost solely by competition in those days. As the country's population had grown, laborers had been increasingly hired to stoke that great engine of enterprise, but the question of who owned the machinery was the critical one, and the inescapable truth was that it had been owned, and for a long time, by corporate entities. Where the American engine of free enterprise was supposed to be going was toward the golden land of unlimited wealth. For a while, it had flown along the road at breakneck speed, but now it slowed to a crawl, slipping toward the ditch of bankruptcy.

During the 1920s, the New York Stock Exchange, the Chicago Board of Trade, and other indicators of the machine's speed had set new records year after year. Then in October 1929, the market crashed, and within months common stocks lost nearly half their value. Factories began to close; people were thrown out of work; the industrial machine sputtered and choked. Within three years, the national unemployment rate stood at one in four, or over 12 million people. Bankrupt businessmen as well as dismissed assembly-line workers found themselves lining the road, peddling apples. Sobered by the sight, Americans began to notice things they had overlooked during the heedless expansionary years. For one thing, the wealth generated by the industrial economy had never been widely or fairly distributed, so that all over the country there were large segments of the population who had never been given much of a ride.

One of the most sobering experiences of the 1930s was the discovery of deep, persistent poverty spread among all ethnic groups but particularly shocking when discovered among older stock Americans. The turn-of-the-century poverty of inner-city tenements, inhabited by immigrants who barely spoke English and who huddled in dirty backstreets, had earlier attracted reformers who won a few significant but local improvements. Likewise, the historic poverty of African-Americans in

the rural South, later migrating to northern ghettos, a poverty stemming from ignorance and racial discrimination, had long been familiar to middle-class whites, although it was generally looked on with apathy. How much more disturbing was it to realize that many native-born whites, whose ancestors may have lived in the New World for centuries and who included landowners working on their own farms, were also poor, and poor even before the dust storms and Depression began. America's boast, and it was a noble boast, had been that poor people had a better chance in this country to rise, build, and acquire property than anywhere else in the world. However true that claim had been, here, staring the nation in the face, was the unmistakable fact of poverty—as bad as anything in Europe, even at times approaching Asian or Latin American conditions—a poverty that belied the promise of America.

What were the root causes of the market crash and the ensuing Great Depression—the sources of that widespread impoverishment, both old and recent, among whites, blacks, and other groups? Historians still disagree among themselves about how to answer such complicated questions. Whatever the answer, this much is certain: beginning in late 1929 a lack of confidence began to spread among corporate executives and financiers, and the economy plunged into a long-term downward spiral of unemployment, a spiral that added hugely to older pockets of poverty.

Kansas, luckily, was not much of an industrial state when the crash occurred. Most of its wealth was in the form of real estate or agricultural capital, not investments in the major industrial corporations, and it seemed for a while that the state might ride out the storm with little harm. William Allen White wrote, "All we can do is to keep on innocently bystanding, and wait."* Soon, however, the ripples from the plunging economy reached even into this state and affected almost every Kansan. The upper classes found their Colorado holidays less affordable. The lower classes had to cut back on shoes and bread.

The economic historian Peter Fearon has shown that in 1932, the bottom year of the Depression, Kansas had 130,000 men and women without a paycheck. The men in that out-of-work army included farm laborers, coal-mine operatives, carpenters, and manual workers of all kinds. Among women, the unemployed were machine operators, saleswomen, midwives, nurses, teachers, cooks, stenographers, typists, and domestic servants.† Commonly, the jobless or underemployed women were single—unmarried, widows, or divorcees—and not able to fall back on a husband's income; it was standard procedure to let the women workers go and give their jobs to unemployed male heads of households.

*William Allen White, *Forty Years on Main Street* (New York: Farrar and Rinehart, 1937), 138.

†Peter Fearon, "From Self-Help to Federal Aid: Unemployment and Relief in Kansas, 1929–1932," *Kansas History* 13 (Summer 1990): 109.

Ethnic minorities, however, were usually the first to feel the despair of unemployment. In Kansas they may have been African-Americans or American Indians or Mexican-Americans. Some of the last were pressured by bosses and relief workers to return to Mexico, if they were not U.S. citizens, but the rest tried somehow to scratch out a living where they stood. Black families shared what food and clothes they had among themselves, but it was not enough to go around. People of all races found themselves scavenging through garbage dumps and trash cans, sifting the scraps thrown out the back door of a restaurant.

By counties, the unemployment numbers were especially high in Cherokee, Crawford, Montgomery, Sedgwick, Shawnee, and Wyandotte. One of the worst hit areas of the state was the mineral area of southeastern Kansas, which had endured low prices for coal throughout the 1920s, prices that had encouraged a new strip-mining technology—massive steam shovels that lifted the overburden of soil away, exposing underground coal seams, a labor-saving technology that put many miners out of work while scarring the land. The Great Depression intensified the miners' plight, provoking them to new levels of anger and a new round of labor-union activity, threatening strikes and sit-downs against the companies. Kansas officials were particularly nervous about growing radicalism in that corner of the state and were determined to stamp it out.

Agriculture was still the biggest source of employment in the state: out of 522,276 gainfully occupied workers in 1930, it accounted for 229,544, including farm operators as well as laborers. Along with agriculture, the related industry of meat packing was a large employer; Kansas ranked as one of the top three states in this industry, after Illinois and New York. Flour- and grist-milling was another major employer, followed by the petroleum industry, in which Kansas was again highly ranked nationally.

The oil fields, like the coalfields, had been through trouble for a long time, wracked by their own strong competitive tensions. An industry overcrowded with small and big producers, it had developed a persistent glut of production. Indeed, the nation's economic machine, running almost exclusively now on fossil energy, was completely awash in fuel. In 1927 there were 600 million barrels of petroleum in storage nationally, awaiting a market. The barrel price of oil, consequently, had fallen to 18 cents in 1931. Then, to control production, the major companies decided to stop buying any output from the independents and to consolidate the industry in their hands. Again, the state found itself at the mercy of powerful outside forces, for Kan-

sas was home to many small, independent oilmen, some of them pumping stripper wells that produced no more than two or three barrels a day. Of course, Kansas was also at the mercy of its own thirst for low-cost energy. One could not enjoy a mass-production, mass-consumption way of life without relying on those major oil companies, although being caught in their power play was intolerable.

As a result of all these industrial and agricultural dislocations, some of them unique to the region, Kansas lost ground to more metropolitan, capital-rich areas. At the time of the First World War, the state had stood at about the national average in per capita income, but by 1933 it had slipped to two-thirds of the average.

The third and final source of dislocation turned out to be the most dangerous of all: a gang of foreign militarists who eventually threw almost the whole world into a long, shattering, costly war. Maybe their rise to power owed something to short-sighted American foreign policy, as some historians have argued, but basically they were the dark spawn of their own societies' frustrated ambitions, nationalist pride, racism, and irrationality. The most demented among them, Adolf Hitler, the illegitimate son of an Austrian servant girl, assumed control of Germany in January 1933 following a collapse of parliamentary government. As dust storms were beginning to desolate Kansas, his Nazi party set out to win supremacy for the master race of Aryans, assassinating Jews, Socialists, Gypsies, and others who disputed its reign. By the late 1930s, Hitler had annexed Austria, had invaded Czechoslovakia, and was preparing to conquer Poland, the Low Countries, France, even the world. His chief ally in this brutal aggression, Benito Mussolini, the head of Italy's Fascist party, had become dictator of his country and started his own domestic reign of terror. Together, the two men aided antidemocratic forces to set up another totalitarian regime in Spain. Even farther from the Kansas scene, on the other side of the Pacific Ocean, still another militarist party was extending its power over the Japanese people. In the year this book of photos opens, Japan's military government signed a pact with Hitler and, intent on winning its own empire in the East, invaded China's northern provinces the next year with bloody success. When General Hideki Tojo, an avowed enemy of the United States, succeeded a civilian as prime minister of Japan, the future became even more ominous. War against the West now became a deliberate strategy and an unavoidable fate. All these foreign events were at first only distant clouds in the Kansas sky, but soon they would swell up to overshadow everything else.

Although Kansans had willingly participated in a ferocious struggle against Ger-

many two decades earlier, losing many sons, they were reluctant to enter another one. They had much else on their mind, and they were tired of dealing with other people's messes. Still, the mass communications of modern life made it impossible for them to ignore what was happening abroad. Daily radio dispatches and movie newsreels as well as newspapers brought reports of grisly killings, rapes, and beatings, as crazed madmen fomented what had been highly civilized nations to commit many barbarous acts. On December 12, 1937, word came to Kansas that Japanese aircraft had sunk an American gunboat, the *Panay,* in waters off China. The *Oskaloosa Independent* was livid about the sinking; the Japanese, its editor shouted, should have been "kicked in the pants long ago and told to stay on its own dunghill."[*] Most local papers were reluctant to stir up too much uncontrollable anger over such a faraway incident and recommended that the country remain calm and safely out of the way of the aggressors.

Unfortunately for that strategy, the poison in the air had already spread within the state's boundaries. Kansas in those years had its own sick and hateful voices, and at least one of them ran for statewide public office. Gerald Winrod, an uneducated, fundamentalist preacher in Wichita, began spouting some of the same racist dogma as Hitler and Mussolini. He claimed to be defending the true, white Christian faith against its enemies and named his publication, with a national circulation, the *Defender Magazine.* He came out against all "modernism" in religious doctrine, along with science, liberals, Communists, lewdness, divorce, booze, government, and what he regarded as an international Jewish conspiracy to achieve command over the earth, threatening Christians and Aryans with slavery. In 1934 Winrod made a pilgrimage to Germany and came back full of praise for the Nazis. Except for a few uniquely backwoods American elements, his message was not essentially different from theirs. Such venom, coming out of a state that not a few years earlier had insisted on its basic goodness and decency, was getting a surprising audience, exposing some of the irrational fears festering under the country's surface. Although when he ran in the Republican primary for the United States Senate, Winrod lost—and most Kansans were relieved that he lost—he still managed to win more than 50,000 votes in this heartland of America.

Contrary to nostalgia, then, this was a time brimming over with hateful doctrines, dangerous militarists, and ruthless nations threatening mayhem and violence. It was a time when the industrial machine broke down, paradoxically loaded with surplus food and fuel but unable to employ a quarter of its work force or eliminate poverty or

[*] *Oskaloosa Independent,* quoted in Bruce L. Larson, "Kansas and the *Panay* Incident, 1937," *Kansas Historical Quarterly* 31 (Autumn 1965): 236.

feed its people adequately. It was a time when Kansas reeled from drought and wind erosion on a gargantuan scale, when tens of thousands of citizens fled. Such was reality in those idyllic days, or at least a large part of reality. Perhaps what was most amazing about our parents and grandparents was that somehow, in the midst of that turmoil, they could find enough peace of mind to go now and then to a pie-eating contest or a picture show.

Note that almost none of the people portrayed in this book are leading politicians of any party. Perhaps the photographers were afraid of getting embroiled in partisanship, but it is a very big absence, for leaving the politicians out may falsely suggest that the ordinary people of Kansas were able or ready to address those threats and dislocations all on their own, without the aid of government. They were not. Quite the contrary, in all aspects of their crisis-ridden lives, they expected politicians to take an interest and devise a solution. Politics, after all, is the effort of people to control and direct events collectively, rather than privately. Here, in this period, events were happening that obviously affected everybody and required a concerted effort to control. Politicians, whose office was to give that direction, were summoned to action at all levels — local, state, national, and international — and those who did not respond were turned out of office and others put in their place. Kansans, then as now, may not have admired the general category of politicians very much, but they spent a great deal of time listening to their speeches, thinking about what they said, admiring individual politicians who touched their hearts, and admitting in so many other ways their dependence on them for leadership.

The dominant politician of this time, a man whose picture appeared almost everywhere but in this photo collection, a man as intensely loved as he was hated, was Franklin Delano Roosevelt, the thirty-second president of the United States. He was from an old upper-class family in the Hudson River Valley, well educated, independent of the corporate economy, a man who had a strong sense of moral duty to help those less fortunate than himself. Roosevelt had had his own charmed life severely disrupted by the crippling disease of polio. Now in the White House, his answer to the national crisis was that the federal government must begin to exert authority over the industrial machine and serve as an instrument of justice and compassion. No radical — indeed, a man of many conservative instincts — Roosevelt became the most important leader, both at home and abroad, of the era.

Roosevelt first came to Kansas in 1932, running for the presidency on the Democratic ticket, and in a well-attended speech in Topeka, he addressed the problems of

*Franklin D. Roosevelt, "A Restored and Rehabilitated Agriculture" (campaign address on the farm problem in Topeka, Kansas, September 14, 1932), in *The Public Papers and Addresses of Franklin D. Roosevelt* (New York: Random House, 1938), 1:695.

rural America. "We have poverty," he reminded his hearers; "we have want in the midst of abundance." Farmers had helped create that national abundance, but as a whole they were not sharing the wealth. As a minority group—and a highly disorganized, independent one at that—farmers wielded little power over events, but working in concert with others, Roosevelt urged, they could improve their unhappy lot.*

Roosevelt called on Kansans to acknowledge that the nation was now a vast economic network in which country and city, industry and agriculture, East and West were joined together. The prosperity of one sector depended on the prosperity of all, and the prosperity of all required a new ethic of "interdependence" among the citizenry. In Roosevelt's view, the federal government was the only institution that could articulate that ethic and turn it into action, uniting the country morally and socially as well as economically.

His program for agriculture called for "national planning," meaning that the government should work out production levels for each farm and limit overall production to what the country needed, thus raising farm prices and helping farmers achieve equality with industry. In that planning, the government should also determine where there were marginal lands that should be taken out of production, restored to nature, rehabilitated from their wasted condition, or devoted to other uses.

Apparently, Kansans liked what they heard in that 1932 speech. They joined the rest of the country in giving Roosevelt a landslide victory over the hapless incumbent, Herbert Hoover. Roosevelt would be returned to office three more times.

The core of Roosevelt's political philosophy became the "welfare state," meaning a government that accepted responsibility for improving economic security and setting minimum standards of wealth for all citizens. Within Kansas, it had support from economics professor John Ise: "Private enterprise, founded upon competition alone, cannot muddle through, and the government has to step in and do what was previously left to business." Similarly, Senator Arthur Capper, although from an opposing party, agreed with Roosevelt to this extent: "The individual is not up to the job in the strenuous industrial game as we play it." And in Emporia, William Allen White editorialized that it was the duty of government to prevent mass starvation, even to provide work when the businessman could not. "On the whole, and by and large, I am for the New Deal," he told a University of Kansas audience in 1934; "it is neither Communist nor Fascist. Much of it is necessary. All of it is human. And most of it is long past due." That solid endorsement of the welfare state,

to be sure, would not prevent White from opposing Democrats at election time. Roosevelt once teased him with being " a very good friend of mine for three and a half years out of every four years."*

During his first term in Washington, Roosevelt and his advisers put in place the major elements of their welfare state. First came a multibillion-dollar program for the unemployed. A new agency called the Works Progress Administration began distributing money to the states for hiring people to work on such projects as fixing roads, building privies, and improving public buildings. The pay was low—a few dollars a week—but it put money into hands that were desperate for it. Among the recipients were Kansas's small band of artists and writers, who prepared a travel guide to the state, taught music classes, and painted post-office murals. A related program gave work-study jobs to undergraduates on the state's campuses, opening those institutions to a broader clientele than the traditional one of the sons and daughters of wealthy families.

Kansas farmers were not eligible for WPA jobs, but they received other kinds of relief, and in dollar amounts it exceeded anything available to the urban poor. Farmers were paid, for example, to take lister plows into their fields and break the wind-swept hardpan into heavy chunks of earth that might slow erosion. They sold their bony, surplus cattle to the government, which canned the meat and distributed it to the hungry.

True to his word, Roosevelt offered farmers a new plan to control surpluses and raise their income. With the support of Senator Capper and others in the Kansas congressional delegation, he set up the Agricultural Adjustment Administration, aimed at cutting back the production of major commodities like wheat, corn, and cotton. The wheat program was especially popular; every county in the state joined it voluntarily. Before the AAA was declared unconstitutional and had to be reformu-lated, Kansans collected $87.5 million in federal payments, just behind Iowa and Texas. Kansas wheat-subsidy checks exceeded those of North Dakota, Oklahoma, and Montana combined. From that point on, farming would never be the same again, as program succeeded program to lessen the harsh impact of the competitive marketplace. Not only did the New Deal help stabilize the income of growers, par-ticularly better-off growers, but it also launched programs of soil conservation and of low-cost loans for rural electrification.

Farmers also benefited from another agency designed to relieve unemployment, the Civilian Conservation Corps, which extended the welfare state into the area of

*John Ise, quoted in Richard B. Sheridan, "The College Student Employment Project at the University of Kansas, 1934–1943," *Kansas History* 8 (Winter 1985/1986): 206–7; Arthur Capper, quoted in Francis W. Schruben, *Kansas in Turmoil, 1930–1936* (Columbia: University of Missouri Press, 1969), 178; William Allen White, quoted in Walter Johnson, *William Allen White's America* (New York: Holt, 1947), 432; Franklin D. Roosevelt, "Rear-Platform Extemporaneous Remarks at Emporia, Kansas, October 13, 1936," in *The Public Papers and Addresses of Franklin D. Roosevelt* (New York: Random House, 1938), 5:465.

environmental renewal. The CCC paid young men a modest monthly wage to work on conservation projects, among them the planting of shelter belts along the section lines to slow wind erosion. Those boys, more than 7,000 of them, sent home almost all their weekly government paychecks to mothers and fathers; it was a lesson in family interdependence.

Undoubtedly, the most famous program of the welfare state was Social Security, established in 1935 as a retirement program financed by a new payroll tax. The same act that set it up also required the states to organize a permanent system of unemployment insurance for their workers. Still another new program, the Federal Housing Authority, funded the construction of dwellings for low-income Americans. Taken together, these many federal programs brought over $2 billion into the Great Plains during the 1930s, more than the region paid in federal taxes, more in per capita terms than any other region of the country received.

Roosevelt returned to Kansas for the 1936 election campaign and traveled eastward by train across the state, stopping in Syracuse, Garden City, Dodge City, Wichita, Florence, Emporia, and Olathe. From the rear platform he denied what his enemies kept charging against him, that he was putting the welfare of one group over that of another; instead, he insisted that he was asking all Americans to transcend the narrow interests of class in order to realize their common interests, to become a nation of mutual aid. "None of these occupations," he repeated the now familiar message, "can survive without the survival of the others."*

Roosevelt's opponent in that second presidential race was none other than the governor of Kansas, Alfred Landon, the only person from his state ever to be a major-party candidate for the White House. A native of Independence, Landon had made a modest fortune in the independent oil business before going into politics as a Republican. In 1932 he had succeeded, despite the Roosevelt landslide, in unseating a Democratic governor, attracting wide attention as a potential candidate in the mold of Hoover, Coolidge, and Harding, all small-town Republican conservatives who had captured American voters in the previous decade. Landon also was praised for having beaten (and retiring permanently from politics) a notorious medical quack and nostrum peddler, John Brinkley, often called "Doc" by those who didn't examine his medical credentials closely. Brinkley had made a pile of money transplanting the glands of Arkansas goats into aging, impotent men. Touring the state in his sixteen-cylinder Cadillac, with a ballad-singing cowboy along for publicity, he had become a minor messiah to many Kansans, particularly in the central part of the state, with his

*Franklin D. Roosevelt, "We Are Coming Through a Great National Crisis with Flying Colors" (campaign address in Wichita, Kansas, October 13, 1936), in *Papers and Addresses of Roosevelt*, 5:458.

promises of free pensions, free county reservoirs, and free schoolbooks. Like another messianic figure among the elderly, Francis Townsend of California (author of the Townsend Plan, which also proposed to give free large pensions to the old), Brinkley understood the painful anxieties of voters who, after a lifetime of hard work at low pay, had to face retirement with little means to pay for their food, housing, or health care. It was a potent issue, but Alf Landon, friendly, unassuming, and honest, swept the field of Brinkley and his other competitors and restored Republican rule to state affairs.

Landon has been called by the historian Donald McCoy "one of the nation's outstanding governors during the 1930s." He earned a reputation for competent, efficient administration and for ideological flexibility—a leader who was aware that the old unregulated economy was no longer tolerable and that government must be concerned about those who could not afford personal security as easily as others. He supported minimum-wage standards for women and children, collective bargaining for labor, as well as old-age pensions and job insurance. His most famous achievement, however, had little to do with the impoverished masses. He worked hard to save the independent oil producers by pro-rating the oil market—giving all producers a guaranteed share—and by erecting tariffs against foreign oil and natural gas. Landon, however, was not so ready to intervene in the market on behalf of other producer groups. His view of the role of government was still a very limited one, emphasizing low taxes and frugality. Once in office, he boasted that Kansas had reduced its state taxes by one-third since the stock market crash. "In our opinion," he declared, "what this nation needs is a program of strict economy from the nation down to the individual."[*]

Cutting taxes was the core belief of many Democrats as well as Republicans, even if doing so meant that the state government could not afford any relief money for the needy or stimulate the economy toward recovery. Relief, it was said, was a strictly local responsibility. Each Kansas county had a poor fund, supplemented by voluntary charity and church bazaars. Some counties also had a poor farm where the indigent and disabled might work to earn a meager subsistence. Such local relief, however, was quickly exhausted; the poor, it was made clear, must not expect anything more than a temporary helping hand or they would lose their sense of responsibility. Rural counties gave out as little as $1.50 a week to a family in need before federal aid came along. Cities could be more generous, but even they faced constraints; often their largest potential donors were absentee owners who took little interest in the

[*]Donald McCoy, "Alfred M. Landon, Western Governor," *Pacific Northwest Quarterly* 57 (July 1966): 125; Alf Landon, quoted in Schruben, *Kansas in Turmoil*, 146.

unemployed or were a local, tax-resisting elite who advocated self-reliance. A large part of local relief funds, consequently, had always come from the lower classes themselves—passing a hat to help a neighbor.

Faced with inadequate local funding, a call for federal assistance came from around the state. When those dollars arrived, they were administered by the Kansas Emergency Relief Committee, headed by John Stutz. Altogether, over 300,000 Kansans received at some point and in some form federal aid, which in percentage of population was about twice the national average. The federal money was supposed to be matched by bigger state appropriations, but in Kansas, as in other states, legislators hesitated to contribute their full share. Kansas ranked thirty-ninth in the nation in state-based relief spending.

In fairness, let it be said that the governor and legislators were shackled by a tight-fisted state constitution requiring that any substantial borrowing must be approved by voters. State leaders feared a backlash if they raised state income or gasoline taxes. They felt they could do nothing. But then Topeka politicians, demanding outside assistance, also demanded that Washington not set itself up as their superior, invade their sovereignty, or try to take over their prerogatives. The Roosevelt administration must give them money—money that they could not, or would not, raise on their own from state resources—and then let them spend it as they felt appropriate, with no strings attached. Landon became an expert at that strategy, stridently calling for cost-cutting in government at all levels, denouncing Roosevelt's "spend-thrift" policies and budget deficits, while calling for help. His opponents, in retaliation, made the telling criticism that Landon balanced his own budget by relying on federal dollars; almost 70 percent of the relief funds spent in the state came from Washington, the counties contributed about 30 percent, while Topeka picked up the rest.

The nation, and even the state, was not ready to buy Landon's view of governmental responsibility when it went to the presidential polls in 1936. Roosevelt won an even greater victory than in 1932, while Landon lost even his home state, even his home county. This time around, a Democrat, Walter Huxman, was elected governor, although five of the seven congressmen elected were Republicans.

The 1930s was a decisive decade for politics in America, for it put the question squarely before the public of how to define the role of government in an industrial age, when most of the goods of life come to the individual through an intricate network of providers, all demanding cash, when dependence on others has become complex and basic. The answer accepted by the electorate was that the old rigid ide-

ology of self-help was no longer valid in a corporate, industrial, international economy. The corollary question of which level of government—federal, state, or local—should take the lead in helping the individual make it safely through the industrial jungle also had a decisive answer: it should be the federal government. The various state capitals all seemed too stuck in outworn thinking, too limited by their tax structure, too unwilling to assume responsibility, too limited in power to control those immense forces of dislocation at work.

Roosevelt's would be the most important presidency since Abraham Lincoln's in shaping modern American life. It was Lincoln who had saved the union from dissolution under the doctrine of states' rights, and now it was Roosevelt who saved it again by inventing the welfare state. Both rescues entailed profound, lasting changes in the way Americans thought about a strong central government. Of course, the political leaders who lead such deep changes can soon lose their personal popularity. In 1940, and again in 1944, Kansans decided they had had enough of Roosevelt and his welfare state; going against the continuing national sentiment, they voted in those elections for his more conservative Republican opponent. Once the worst of the industrial crisis passed, once farm income began climbing again, many Kansans wanted to shake free of the new, more intrusive, expensive federal presence, with all its controls, regulations, and restraints on their economic freedom. They would never go back to the old rugged individualism, of course, but they would like to think they could.

The winds of war meanwhile were blowing hotter and hotter, sweeping over whole continents. The German blitzkrieg, a sudden lightning attack by air and land, crushed Poland in 1939, forcing Britain and France to cease issuing cautionary words and declare war. Within another year France fell, and Britain stood alone in the West to fight the Nazis, who sent their V-2 rockets screaming into the English skies. The United States watched from the sidelines while England, if not all of Europe, threatened to succumb to a paranoid dictator. President Roosevelt, more and more worried by these events, set his domestic agenda aside in order to ease the nation, gradually and cautiously, into a posture of self-defense. He pushed a military draft through Congress along with a rearmament program that would come to the aid of Britain's gritty defense as well as gird up American might.

Kansans were divided over these threats, more than they had been over any issue since the nineteenth-century struggle for statehood. Their delegation in Washington, led by the arch-pacifist senator Arthur Capper, staunchly determined to stay out

*Arthur Capper, quoted in Philip A. Grant, Jr., "The Kansas Congressional Delegation and the Selective Service Act of 1940," *Kansas History* 2 (Autumn 1979): 199.

of the war, reject the draft, and spend little on weaponry. They threw the word "dictator" at Roosevelt as much as at Hitler. Capper warned that "compulsory military service in peacetime is a step toward dictatorship."* Freedom at home, he believed, required nonintervention in the world's unholy affairs. Others saw in his pacifism a less noble sentiment—"isolationism"—and no state seemed to fit that label better than Kansas, burying its head in the dust while the planet ran red with violence. Yet even in this intensely antiwar state, there were those who saw no alternative to fighting. The most vocal among them was William Allen White, who became head of the Committee to Defend America by Aiding the Allies, although even White was reluctant to send U.S. troops into the European arena, hoping that Britain could single-handedly stop the Nazis with the help of American equipment. The harsh debate over involvement raged on and on, until in December 1941 it was abruptly silenced by an unexpected Japanese attack on American soil.

The surprise bombardment of Pearl Harbor came late on a Sunday morning while many Kansans were still in church. Returning home, they fearfully tuned in to get the grisly news and to hear the president call this "a day that will live in infamy." That afternoon, at 3:12 P.M. Kansas time, Congress declared war against Japan, with the entire state delegation joining in the vote and pledging its support.

The next day, newspapers across the state unanimously supported the decision to go to war. The Wichita *Beacon* described "a fighting-mad" citizenry rallying behind the president, determined to keep "the ceaseless flow of defense materials from this area . . . to America's armed forces." The Garden City *Telegram* reported that young men had shown up at the recruiting station at daybreak, ready to enlist: "The attack created here, as elsewhere, a unity that had been lacking before." A navy man on furlough predicted to the Emporia *Gazette* that it would require only a few months to "take care of the Japanese." Wrong in his timing, nonetheless like many others he was sure that, when sufficiently aroused, Americans could not lose. "The day of reckoning will come," said the Topeka *Daily Capital,* "a sad day for those who unleashed the paganistic doctrine of force upon a civilized world." One of its reporters, "walking through the downtown sections of the city, . . . was amazed at the unanimity of opinion. The Japanese have attacked the American flag, sunk American ships, and killed thousands of American soldiers and civilians. The United States must retaliate. Those are the things the people said." What the people also sensed was that the country was heading toward war with Germany and Italy too, and within days those nations would make that condition official. The *Beacon* pointed out that "it was

Hitler striking at Hawaii. It was Hitler flying over the West Coast. The elimination of the Japanese will not end the matter. We must go on and finish the job finally and completely . . . until [Hitler] is finished there will be no security for any man or woman on this earth."[*]

Few could see that early December that they were facing a long, expensive, and deadly engagement, more deadly by far than the Depression or dust storms had been. They would end up sending 200,000 of their sons and daughters into service, many into mortal combat, a great number of whom—4,250 in all—would never come back. Some would end their lives in a submarine sinking to the Pacific floor or in a fiery plane crashing over Europe, or they would die of gangrene in a field hospital.

Roosevelt's welfare state now grudgingly gave way to the warfare state. Overnight, the federal government exploded in size, far beyond anything it had been during the New Deal with all its alphabet agencies. Office buildings in Washington were soon overcrowded, their staffs shorthanded. National debts began to pile up and up and up, dwarfing anything Roosevelt had incurred in the fight against poverty and drought. America was entering a new phase in its history, becoming exactly what Capper had feared: a great armed power intent on maintaining a global military presence for decades to come. That militarization would have profound effects on the Kansas economy and on Kansans' personal sense of security. From this point on, they would be deeply anxious about insidious, seditious enemies within as well as enemy hordes without.

Why did virtually all Kansans and other Americans accept so unanimously a massive federal mobilization in 1941 when so many had so firmly opposed it to fight poverty during the 1930s? Why was Big Government tolerated to pursue war and retribution abroad but not to pursue economic justice and soil conservation at home? Clearly, the war stimulated an intense nationalistic spirit that overwhelmed traditional antigovernment ideology. Growth in government became more acceptable when it was for the defense of American freedom, honor, security, and territory. As a side effect, the rapid rearmament stimulated the economy tremendously—creating by indirection a massive antipoverty program, although one based on violence and war.

In small Kansas towns as well as industrial cities, men began to patrol the skies and roads, on the lookout for saboteurs and fifth columnists. Newspapers explained what to do if there was an air raid by German or Japanese bombers. Kansans prac-

[*]"Wichita Population Prepares for War," Wichita *Beacon,* December 8, 1941; "Garden City Quiet, But Mad," Garden City *Telegram,* December 8, 1941; Jim Bell, "Topeka Calm and Determined as Nation Goes to War for Second Time in Generation," Emporia *Gazette,* December 8, 1941; Topeka *Daily Capital,* December 9, 1941; "No Time Now for Recrimination," Wichita *Beacon,* December 9, 1941.

ticed blackouts, just as Londoners were doing. When a Japanese surveillance balloon landed on a farm near Bigelow, the authorities were immediately on the scene to confiscate it. Every industry, every machine, required super-vigilance. Every farmer had to become, in his way, a soldier of democracy. No sacrifice, no expense, no regulation was too onerous to bear if it meant winning the war.

Wichita became the preparedness center for the state, and indeed an important center for the nation, as its aircraft industry went into round-the-clock production. This would be a war fought in the air as much as on the land or at sea. As men went off to fight, an army of women took over making the weapons of the air. By 1943, 31,000 women held jobs in Wichita, many of them dressed in coveralls, wearing a security tag with a Cessna, Beech, or Boeing insignia. The influx of war workers required prefabricated housing bolted together almost as fast as the planes came off the assembly line—and that was four planes a day at peak. Per capita, Wichita had the highest war contract volume of any American city, and its future as Kansas's largest city would be determined by that wartime activity and its postwar sequel.

The most potent war machine that came out of Wichita, from 1943 on, was the B-29 Superfortress heavy bomber; almost half of them were made in that city alone. Eventually, the B-29 carried the war right into the heart of Japan, flying high over fighters and antiaircraft guns, dropping explosive fire on factories, rail lines, government offices, and whole tinderbox neighborhoods of wood and paper houses. In March 1945, 325 of the planes flew out together to ignite a firestorm over Tokyo, and they left behind them more than 100,000 people dead. By the summer of that year, the planes had made more than 20 million Japanese civilians homeless. Then in August it was a B-29, the *Enola Gay,* that dropped the first atomic bomb on the city of Hiroshima.

The revolution going on in warfare was seen not only in the Wichita aircraft industry, but also in Fort Riley, near Junction City. Photos in this book show the old romantic cavalry, dating back to the days of General George Armstrong Custer, still drilling on the prairie. There were still black regiments climbing into the saddle (descendants of the famous buffalo soldiers) as well as white ones, going out on patrol with their pennants flying. But now the horse cavalryman was a quaint anachronism, for it was heavy convoys of motorcycles, jeeps, trucks, and tanks that would move this modern army to the front.

Historic Fort Riley itself was only one among many military bases expanding across the state. There was the Hutchinson Naval Air Station, established in 1942 on

land purchased from Amish farmers, and another one at Olathe. There were army air stations at Coffeyville, Independence, Arkansas City, Winfield, Topeka, and Garden City; and there was the Smoky Hill Air Force Base near Salina, the largest military installation in the state and the third largest air base in the nation. In many ways, this intensely inland state, despite its traditional sense of living isolated from the rest of the world, now had many connections abroad—connected by the power of flight, by an instrument of destruction now droning over faraway islands.

Among the men stationed at Fort Riley was Joe Louis, the heavyweight boxing champion. African-Americans like him played a prominent role in training for and fighting in the war, and their experience helped change the terms on which they would live within postwar American society. If Hitler's doctrine of racial superiority was evil in Europe, why, many blacks asked, was an all too similar racial prejudice and segregation accepted in the United States? Blacks began more vigorously than ever before to assert their long deferred claims to justice. At the University of Kansas, black students had long been excluded from the dormitories; they often had to sit in the back of classes; they could not join the band or glee club or go to student dances, even when a famous black performer, such as Count Basie, played the music. The Fort Hays State Teachers College had excluded them totally from campus. Now, however, the National Association for the Advancement of Colored People insisted that blacks would not fight in their country's wars without receiving fair and equal treatment at home. Like women, Kansas's racial minorities found the war opening up new possibilities for them to challenge traditional stereotypes and patterns of discrimination.

Little is known about the war's impact on local Japanese-Americans, although there seems to have been far less hysteria about their presence in Kansas than on the west coast. Perhaps they were too few to notice, let alone resent. On the day after the bombing of Pearl Harbor, the Topeka *Daily Capital* claimed there was no outburst of hate in that city: "[N]o gangs went looking for Japanese to hang to street lamps. Even if they had, none would have been found."[*] Nor did German-Americans face the degree of hostility they had faced during the First World War. The German language continued to be taught and German music to be performed. Even German prisoners of war, brought to the state from the European theater, did not meet with much bitterness; in the Concordia POW camp, they were well fed on Kansas food, sending surplus rations back home to feed their families, and some went to work as farm laborers, forming local friendships that would survive the war.

[*]Bell, "Topeka Calm and Determined."

For everybody it was a difficult way to live, hedged about with severe government-imposed restrictions that made privation a truly shared experience for the first time. All citizens, regardless of wealth, had to carry books of ration coupons into the grocery stores and scramble for scarce supplies of sugar, coffee, and meat. Where beef had been in surplus a few years earlier, now consumers found only a few tiny, leathery steaks available at the butcher shop. A Wichita Sunday-school teacher, Gail Carpenter, in his monthly letter to the hometown boys overseas, quipped that he felt guilty consuming such "leather" when it was needed by the army. Many city dwellers grew so-called victory gardens to furnish more of the families' food. Wichita, said Carpenter, was full of such gardens, and "even the curbing is green with straight well cultivated rows of vegetables."*

*Charles William Sloan, Jr., ed., "The Newelletters: E. Gail Carpenter Describes Life on the Home Front: Part Two," *Kansas History* 11 (Summer 1988): 128.

Everyone but farmers had to get by on less gasoline; there was no longer a fuel glut but a fuel shortage, and drivers could buy only four gallons a week for their passenger cars. They had to observe a highway speed limit of 35 miles per hour to save gas and tires. After the Japanese invaded Southeast Asia and took over its large rubber plantations, tires became a precious commodity—and a flat tire a real calamity. Joy riding in the country or up and down Main Street was out of the question.

Farmers, in contrast, could get all the gasoline they needed to raise crops, and now there was an insatiable market, at home and abroad, for whatever they could produce. Like an act of divine providence, the rains returned to Kansas in 1941, just in time to make possible the push for all-out production, planting fence row to fence row. Farmers' worst shortage now was labor, not moisture, and fortunately it was women again who marched into the fields that men had left behind and did what had to be done. Across the country, the Women's Land Army of America signed up women to work on farms. Older men and young boys, ineligible for military service, came out to get the wheat harvested too. Production surged and so did farm income, soaring to twice what it had been from 1936 to 1940. Wheat rose to 98 cents a bushel; corn, to 68 cents.

By 1945 farm conditions had improved dramatically all over the state. Long-standing debts and taxes could be paid at last. The value of all crops sold in that year was $300 million, compared with $87 million in 1940. The total value of livestock and livestock products sold made a strong comeback too.

Fewer farmers were left to share the revived abundance. In 1945 there were 33,000 fewer of them than ten years earlier. The number of tenant farmers had also dropped, due less to government success at transforming tenants into owners (an effort cut

short by a Congress fearful of creating competition for existing owners) than to market pressures.

With more money to disperse among fewer hands, farmers could afford more radios, telephones, automobiles, trucks, and tractors than ever before. However, only a few had managed to acquire electricity or running water. Over 100,000 Kansas farms reported no running water as late as 1945. A large majority still had no electricity, despite the Rural Electrification Administration's efforts, as farmers had proved reluctant to take on even heavily subsidized government loans.

The war that these people on the domestic front worked so hard to support, and that they supported so well, the war that they discussed so endlessly around the radio, reading together letters from sons or lovers, began at last to tilt their way. By late 1942, the United States, Great Britain, and the Soviet Union began to press the enemy back relentlessly, first in Africa, then in Italy, then on the eastern front, then in the fields of France. Finally, on May 8, 1945, the Allies achieved victory in Europe. Germany surrendered unconditionally. The next month, the Allies' commanding general who had accepted that surrender, Dwight Eisenhower, returned to Abilene, Kansas, his hometown, to visit his mother, Ida, and there was greeted by 25,000 joyous citizens, proud of their role in defeating tyranny but relieved that the war was nearly over.

Not all the news was good. Roosevelt, in the last days of the war, died of a cerebral hemorrhage. In his place, humble and a little uncertain, sat a new national leader— Harry Truman, the man from Independence, Missouri. It was Truman who had to make the final awesome decision of the war, to drop the atomic bomb on a stubborn Japan. After enduring a black rain of death and radiation, Japan too surrendered to the American forces. By August 1945, the war on both fronts was over at last.

So was the Great Depression, and so was the dust bowl. They all passed thankfully away, although they left scars that would last a lifetime—empty places at the table, bitter memories of hardship, dirt piled up in the attic.

One of the photographers in this book, John Vachon, said, "I was supposed to be taking pictures to show that this was a great country and I was finding out it really was. . . . I didn't know it at the time, but I was having a last look at America as it used to be."* He was right; it was indeed a great country, never more so than when it faced some of its darkest problems ever and courageously tried to solve them.

The generation of the 1930s and 1940s had gone through tremendous, irreversible changes, as sweeping as any American generation had ever had to face. Most contro-

*John Vachon, quoted in O'Neal, *Vision Shared*, 283.

versial, there was the ubiquitous growth in the federal government, spreading into all corners of the land. The private corporate structure of power over the economy had not changed much, but there was now a greater economic security for the masses ensured by that government. The country was more consciously diverse than ever before in racial, ethnic, and religious terms — and more challenged than ever before to try to come to terms with that diversity. America was now a society in which many women had held jobs outside the home, and although giving them up to returning veterans, many were not willing to go back to a life in the kitchen. Most Americans had gone without consumer goods for many years, and now they were ready to go on a postwar buying binge — looking for all-electric homes in the suburbs, flashy automobiles in their garages, a television set in the front room, a house full of ingenious appliances. They would begin all over the giddy pursuit of that old dream of unlimited economic growth, although soon another round of deep ecological crises would begin and would require relearning some of the old lessons of limits and frugality.

What, then, can we say about that solid, decent state of Kansas, which had outgrown its wild and woolly frontier days only to find itself swept up in the age of the mushroom cloud? More than ever, it was part of a complex technological society, sharing its dynamic, mysterious, powerful energies. Kansans found themselves living on the periphery of that society, ignored most of the time, sensitive about their marginal status but not altogether unhappy about it. Henceforth, the state would be tugged along more and more rapidly by distant forces of capital, government, and foreign affairs — tugged and pulled in so many directions, and not a little bewildered by the world around it.

Had they learned anything from these tumultuous years? Yes, of course, they had learned a great deal, although probably not as much as they should have. Learning, after all, requires quiet reflection. They had not had much time for that. They had been pretty busy surviving the ordeal.

CREATING THE PHOTOGRAPHS

Roy Stryker and Documentary Photography

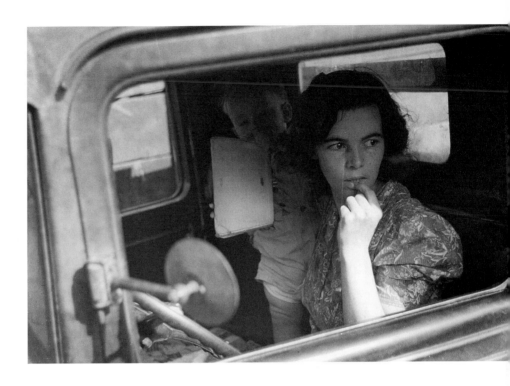

The overworked cliché "A picture is worth a thousand words" overlooks a crucial caveat: pictures, especially photographs, however beautiful, are worth very little as historical documents when taken out of context. The photographs in this "camera's-eye view" of Kansas are beautiful, but they are the result of a particular set of circumstances that shaped decisively what the photographers included, as well as what they did not include, within their viewfinders between 1936 and 1949. Just as a review of the turbulent local, national, and international forces that shaped Kansas between those years forms one part of the historical context for these images, the stories of the institutions and people who created the photographs form another part of that context.

The photographs in this volume were made by three different but related documentary-photographic projects established and run by Roy Emerson Stryker (1893–1950) to record selected parts of the national experience during the Depression and

wartime years. These projects—part of the larger work of the Farm Security Administration, the Office of War Information, and Standard Oil of New Jersey—are usually known to students of photographic history by their initials: FSA, OWI, and SONJ. The first two of these projects were funded by the federal government; the last, as part of a public-relations campaign of a major corporation. In each project, Stryker and his photographers had a broad mandate to document the impact of depression, war, and the petroleum industry on the daily lives of the American people.

The personality and direction of Roy Emerson Stryker lie at the heart of the images of Kansas reproduced in this book, although what brought his general directions and broad purposes to life were the decisions and vision of particular photographers, realized in the vivid individual images that form his and their lasting legacy. Stryker was a Kansan, born in Great Bend in 1893, three years before his family moved to Colorado. In one corner of his mind Stryker always remained a small-town boy from the West for whom the land was important and the education of farmers a way to preserve it. After serving in France during the First World War, and then working on a ranch and attending the Colorado School of Mines in Golden, Stryker moved to New York City with his new wife, Alice, worked at the Union Settlement House there, and became an economics undergraduate and then graduate student at Columbia University.

At Columbia, Stryker became first the student and then the protégé of a young economics instructor named Rexford G. Tugwell, whose scholarly interest during the 1920s was agricultural economics. As a student assistant, Stryker began his lifelong interest in photography as a tool for teaching and learning about society while searching for illustrations for Tugwell's book *American Economic Life* (1925). Stryker taught at Columbia until 1930, incorporating into his courses the photographs he found for Tugwell. Tugwell thus had a twofold impact on Stryker's later work as director of the three photographic projects. The western farm boy who had direct experience with agricultural work and its hardships became under Tugwell the trained economist who understood the larger economic forces of rural poverty and had come to regard photography as a tool for visualizing those forces and their effects.[*]

The opportunity to put these points of view to work came in 1935 when Tugwell invited Stryker to work for him again—this time in Washington, D.C. Tugwell had been given the task of organizing the Resettlement Administration (RA), an execu-

[*]F. Jack Hurley, *Portrait of a Decade: Roy Stryker and the Development of Documentary Photography in the Thirties* (Baton Rouge: Louisiana State University Press, 1972), 3–14.

tive agency created by Franklin D. Roosevelt to help the poorest farmers, both tenants and small landowners. The new agency was named Resettlement because Tugwell assumed that farmers on marginal land could not become efficient enough to escape the poverty that trapped them, and thus had to be moved to urban centers as laborers or resettled on larger experimental cooperative farms. Tugwell also proposed building cooperative rural communities and creating model migrant-labor camps. Between 1935 and 1937, the Resettlement Administration took over programs from other agencies and developed programs of its own to serve the poorest farmers of the nation.

Much of this cooperative enterprise seemed to its critics to be a kind of socialism, however, and by the end of its short life, the RA had shifted its focus to developing programs aimed at the rehabilitation of poor clients who did not want to be resettled. Rural rehabilitation involved a wide spectrum of activities, most of which required federal loans. These ranged from individual loans, enabling farmers to purchase feed and seed or to deal with immediate subsistence emergencies, to group loans, encouraging client families to organize cooperatively for purchases of costly equipment or other shared resources. In spite of this shift, however, political difficulties led to administrative change in the agency. Tugwell resigned, turning over the functions of his agency to the Department of Agriculture. In July 1937, Congress passed the Farm Security Act, which legitimized some (although not all) of the RA's efforts to help the poorest third of the nation's farmers. Secretary of Agriculture Henry A. Wallace renamed his newly acquired and authorized agency the Farm Security Administration.

The FSA no longer operated under Tugwell's mandate to wage war on chronic rural poverty, but on the more cautious agenda to reduce farm tenancy and preserve small family-farm ownership. Its activities inherited from the RA included loan programs, efforts at rural cooperation, medical and dental care for rural clients who could not afford these services, and debt-adjustment programs under which FSA staff helped indebted rural clients renegotiate their loans with banks to reduce farm foreclosures and bankruptcy. By 1946 when the FSA was dismantled, the rehabilitation loan program had extended $1 billion of credit to 893,000 farm families—one out of every nine in the United States, over half of whom had already repaid their loans in full. Smaller amounts for which no repayment was required were distributed by the FSA under emergency relief grant programs. This division of the FSA con-

centrated its efforts in the drought-stricken northern Great Plains, and some of the Kansans pictured in these photographs received such FSA grants. By 1943, this program had dispersed $136 million to 500,000 families.

The most controversial of the rural rehabilitation programs were those that fostered cooperative activities. The most widespread of these were Group Services loans by which neighboring client families could purchase breeding stock, farm machinery, and other facilities together. More than 25,000 cooperative groups, including many in Kansas, eventually established themselves with the help of FSA staff and received money to drill wells and to purchase tractors, combines, and other equipment.

Despite its considerable successes, the FSA and its programs faced substantial opposition in Congress, particularly from southern legislators. By 1943 when the Second World War had shifted national attention away from economic recovery and rural poverty and toward wartime production, Congress sharply reduced FSA funding and began to dismantle its most successful programs; in 1946 it abolished the agency altogether, shifting its few remaining loan programs to the newly created Farmers Home Administration.[*]

*Sidney Baldwin, *Poverty and Politics: The Rise and Decline of the Farm Security Administration* (Chapel Hill: University of North Carolina Press, 1965), 198–213.

The photographic record created by the Resettlement Administration and its successor, the Farm Security Administration, played a crucial role in educating Congress and the public about the problems of rural poverty that these agencies had been created to solve. Tugwell believed strongly that public relations formed an important part of the task that his new agency had to undertake. It was this job that he entrusted to Roy Stryker when in 1935 he invited him to head the Historical Section within the RA. Tugwell envisioned that the section would assemble a body of striking photographic documents that his and other New Deal agencies could draw on to illustrate reports, prepare exhibits, and lend to journalists and others writing about agricultural reform. But Stryker the economist had learned from Tugwell at Columbia that any problem had complex origins and must be approached from many different angles. Under Stryker's direction and leadership, the Historical Section accumulated between 1935 and 1943 a massive file of photographs that documented the agricultural conditions of every corner of the nation. "The File" went far beyond public-relations images of RA or FSA actions, agents, and successes, reflecting the reform-mindedness of its director and many of its photographers.

The work of the Historical Section began on a small scale. To help him acquire

the photographic images he would need, Stryker brought with him from New York a former Columbia University graduate student, Arthur Rothstein, who had some experience as a photographer and took charge of setting up the photographic laboratory. Three experienced photographers — Carl Mydans, Walker Evans, and Dorothea Lange — soon joined the section and played an important role in sharpening Stryker's vision of the section's mission. Mydans, a journalist, taught him about the value of the new technology of 35-mm film, whose smaller cameras allowed photographers more mobility and enabled them to produce more candid photographs of the sometimes shy clients of the FSA. Evans, by contrast, working in the tradition of the great photographer Alfred Stieglitz, saw documentary photography as an art form rather than simply as a visual record. He articulated to Stryker an aesthetic ethic about the importance of a photograph as an artistic statement above and beyond its informational values. And Lange, who had been a portrait photographer in Berkeley, California, brought to the RA/FSA Historical Section a deeply felt social conscience and the belief that photography should be harnessed to the fight to improve conditions for victims of the economic crisis. Although of these four only Rothstein ever worked in Kansas, all had a profound effect on the images produced by the section there.[*]

By the time the RA became the FSA in 1937, the Historical Section had established an efficient working routine. Stryker dispatched photographers with detailed instructions of the kinds of images to look for, known to the photographers as "shooting scripts," which rather than dictating a preconceived story were meant more as a guide for creating an awareness of the multiple approaches from which farm and rural-community problems ought to be studied and then recorded photographically. During the photographers' extended travels, Stryker kept in touch with them by telegraph and long letters of reaction, instruction, and observation. Photographers requested and received at postal boxes and hotels all over the country camera equipment and film supplies from headquarters in Washington, where staff in a well-run darkroom developed the film and printed the proofs from which Stryker selected images to send back to the photographers in the field for captioning. Thus the captions used in this book were written by the photographers shortly after they had taken the pictures. The Washington office became the home of a growing archive of captioned photographs used extensively for illustrations by newspaper, magazine, and book editors; FSA and other government agency heads in their reports; and agricultural reformers. More than any other source, Stryker's files became

[*]Hurley, *Portrait of a Decade,* 40–54. For brief biographical sketches of individual photographers mentioned, see Hank O'Neal, *A Vision Shared: A Classic Portrait of America and Its People, 1935–1943* (New York: St. Martin's Press, 1976): for Walker Evans, 60; for Dorothea Lange, 75; for Carl Mydans, 115.

*Carl Fleischhauer and Beverly W. Brannan, *Documenting America, 1935–1943* (Berkeley: University of California Press, 1988), 338–40. Roy Stryker's correspondence with the photographers is available in a microfilm edition, *Roy Stryker Papers, 1912–1972* (Microfilming Corporation of America, 1982).

†Hurley, *Portrait of a Decade*, 96–102.

‡Roy Stryker to Jack Delano, 8 April 1941, quoted in Fleischhauer and Brannan, *Documenting America*, 5.

the visual memory bank of the Depression years for both contemporary and later users.*

During the eight years in which the file grew, its focus gradually expanded beyond and moved away from the agricultural record and reform goals under which it had begun. In late 1936, after a series of conversations with sociologist Robert Lynd, author of *Middletown: A Study in American Culture* (1929), Stryker expanded the mission of his photographers to capture a broader cross section of American life that included its small towns. Russell Lee was particularly skillful in doing this, and his photographs in this book of the 4-H Club Fair in Cimarron, Kansas, are part of that effort. Not entirely coincidentally, the effort to document the ordinary daily routines and special events in the life of a small town created a subtle shift toward less controversial subject matter at a time when the FSA and its work were facing congressional and public scrutiny.†

Two years later, the outbreak of conflicts in Europe that presaged the Second World War created another shift in the section's emphasis. Increasingly, agency funders and clients wanted photographs of the preparation for war rather than of the conditions under which FSA clients struggled for economic improvement. In celebrating the all-American virtues of small-town life and in preparing Americans for the war effort, a not-so-subtle difference in perspective emerged: "affirming photographs" and "the American habit" became regular items on the shooting scripts from Stryker that photographers took with them on assignment. Stryker took on war-preparation assignments from other agencies as well, as part of a strategy to protect his agency from congressional criticism. "It is very important that we keep our finger in defense activities the way the whole world is moving now," he wrote in 1941 to Jack Delano. "I am determined that we are not going to find ourselves liquidated because we got on the wrong wagon."‡ Throughout 1941 and 1942, his photographers were increasingly sent to find stories and images of the transportation industry coping with increased production, of vital wartime industries such as oil, of soldiers standing on street corners, and of aircraft workers turning out planes for the war effort.

One of the most important "client" agencies to which Stryker turned to keep the Historical Section functioning in the face of severe FSA budget cuts was the Office of War Information. Begun in July 1941 as the Office of Coordinator of Information, created to coordinate a proliferation of government propaganda and information efforts, in June 1942 it was renamed the Office of War Information and lodged within the Office of Emergency Management. By late 1942, Stryker and OWI Associate

Director Milton Eisenhower had arranged a transfer of the Historical Section from the FSA to a subdivision of the OWI's Domestic Services Branch. Although photographers, photographic files, headquarters staff, and the general approach toward recording the American people and their activities remained under Stryker's direction, he quickly discovered that he had far less discretionary power under these new circumstances. Faced with congressional questioning of the wartime utility of its work and the loss of its photographers to the draft, the Historical Section and its enormous file of photographs faced a crisis.[*]

Rather than staying within the growing bureaucracy of the OWI to fight for the section's survival, Stryker began to explore strategies for preserving the photographic archive that he and the section had created. The more than 107,000 photographic prints created or gathered by the FSA and the OWI constituted a unique visual record of American life, documenting a broader range of rural, urban, and small-town activities than any other government agency has recorded before or since. Worried that the file would be dismantled and dispersed under the pressure of wartime propaganda needs if it remained within the OWI, Stryker arranged for its transfer to the Library of Congress in late 1943, and then resigned from the government. He was fifty years old. For two decades, he had been deeply involved in using photographs to teach economic and social truths about the nature of American rural and small-town life. To the surprise of many of his progressive reform-minded friends, rather than simply retiring, he turned to a new phase of the visual recording of American life with the funding and support of an unlikely sponsor: Standard Oil of New Jersey. On October 4, 1943, Stryker signed a contract with the nation's most controversial oil company and moved himself and several of his FSA/OWI photographers to its New York headquarters.[†]

How a committed economic reformer who remembered his Populist farmer father praying loudly, "Please God, damn the bankers of Wall Street, damn the railroads, and double damn the Standard Oil Company!" came to be part of the public-relations efforts of the firm his parents abhorred is a story that reflects not so much on the open-mindedness of both parties as on the frustrations that each faced in 1943. Standard Oil of New Jersey was in deep trouble. The largest of the seven smaller oil companies created when the Sherman Antitrust Act destroyed John D. Rockefeller's national monopoly, SONJ had grown during the 1920s and 1930s into an international marketing giant. In late 1929, it had agreed with a leading German competi-

[*]Hurley, *Portrait of a Decade*, 162–68; Fleischhauer and Brannan, *Documenting America*, 6–7.

[†]For a discussion of the number of photographs produced by the agencies, see Fleischhauer and Brannan, *Documenting America*, 330–35. Stryker's move to Standard Oil is described in Steven W. Plattner, *Roy Stryker: U.S.A., 1943–1950, The Standard Oil (New Jersey) Photography Project* (Austin: University of Texas Press, 1983), 15.

tor, I. G. Farbenindustrie, on what seemed at the time a practical compromise: SONJ would not compete with Farben in the costly experimental race to develop an oil-based synthetic substitute for rubber, and in return Farben would not enter the American petroleum-products market.

What was hailed as a wise marketing decision in 1929, however, took on a much more sinister appearance a decade later when the German corporation became not simply an aggressive economic competitor but part of the industrial support of a wartime enemy. A series of highly publicized congressional hearings in 1942 into wartime shortages of the rubber essential for keeping a mobile army and a domestic war-production economy supplied with tires blamed the problem on Standard Oil of New Jersey, despite Secretary of Commerce Jesse Jones's admission that the federal government had refused to fund the research and development of synthetic rubber because of the potential expense. Senator Harry Truman of Missouri growled that the SONJ pact with Farben "approaches treason." The company needed a public-relations miracle.[*]

[*]Plattner, *Roy Stryker*, 12.

To refurbish its tarnished image, SONJ turned to one of Madison Avenue's most talented public-relations firms, Earl Newsom and Company, which suggested that the company create a documentary photographic record of all the positive ways in which the oil industry had an impact on American life. Approached by the ad agency's photographic director, Edward Stanley, who had known him during his FSA days and had worked with him briefly in the Domestic Services Branch of the OWI, Stryker agreed to take on the project. It seemed to him an opportunity to continue in a new direction the documentation of American life, to which he had already devoted a rewarding decade of his life.

Stryker brought to the Standard Oil project many of the same field techniques and philosophical approaches that had served him so well at the FSA and OWI. In conversations and correspondence with photographers, he reminded them again and again, "You are not just photographing for Standard Oil. You are photographing America. You are recording history." By the time he and the thirty photographers who worked for him ended that project in 1950, they had amassed another 68,000 images at a cost of almost $1 million. To ensure the widest distribution of its new image, SONJ opened up these photographic files to anyone who wanted to use them, free of charge, requiring only the use of a credit line bearing the names of the company and the photographer. Nearly 50,000 prints from the file were distributed in 1949 alone.[†]

[†]Ibid., 18–19; Ulrich Keller, *The Highway as Habitat: A Roy Stryker Documentation, 1943–1955* (Santa Barbara, Calif.: University Art Museum, 1986), 46–48.

The new archive of oil-related photographs achieved Stryker's goal of telling another side of the American story, but they were less successful in solving Standard Oil's more immediate problems. As early as 1948, the company directors began to question the project's substantial expenditures, and when a series of Roper polls showed little change in the company's public image, Stryker's budget was cut. In 1950 he resigned. For another ten years, SONJ continued to use the files, but decided to abandon them in 1960 as irrelevant to its needs. Prints and negatives were transferred to their present home at the University of Louisville, to which Stryker also gave his personal collection of FSA, OWI, and SONJ prints, as well as his correspondence and other personal papers.

The photographs produced by Stryker's three projects have come under fire from two different groups of critics. One argues that they are more works of art than of historical record: as art, the images were deliberately shaped by the photographers using aesthetic criteria, and thus they are regarded by these critics as artificial creations rather than accurate portrayals of reality. The other critics point to the propaganda agenda of government and industrial public relations that lay at the heart of the photographic missions to argue that the images are deliberately misleading. Despite such criticisms, most Americans have responded to these photographs as a valid and essentially accurate slice of our national life, taken at a time when that life was threatened by depression and war. Although other government agencies made a photographic record of their activities and documentary photography came into its own in the popular media through magazines such as *Life* and *Look,* it is the work of the FSA and OWI that has had the greatest impact on Americans' visual memories of the Great Depression and the home front at war.[*]

Roy Stryker once described himself as "just a guy that hangs around the office and gets paid for buying film and keeping the nuisances away from the photographers so that they can go out and get something done."[†] In spite of his modesty, his legacy is a remarkable one that has had uses far beyond even his own extensive vision. Increasingly, the images that he and his photographers created as a means to see and solve national problems by focusing on them at the state and local level have become a source for individuals and communities to focus on their state and local identities and experiences during the crucial decades of the 1930s and 1940s. The photographs in this book invite Kansans and their friends to take part in that process, remembering through their challenging and nostalgic imagery a past that has helped to shape the present.

[*]James Curtis, *Mind's Eye, Mind's Truth: FSA Photography Reconsidered* (Philadelphia: Temple University Press, 1989); Alan Trachtenberg, *Reading American Photographs: Images as History, Mathew Brady to Walker Evans* (New York: Hill and Wang, 1989); James Guimond, *American Photography and the American Dream* (Chapel Hill: University of North Carolina Press, 1991), esp. chap. 4.
[†]Roy Stryker, in a lecture at the Institute of Design, Chicago, 12 August 1946, in Keller, *Highway as Habitat,* 201.

THE PHOTOGRAPHERS & THE PHOTOGRAPHS

ARTHUR ROTHSTEIN

Arthur Rothstein (1915–1985), a native of New York City, was the first photographer to join the Historical Section of the Resettlement Administration. Only twenty-one years old and just barely out of graduate school at Columbia University when he went to work for Roy Stryker in July 1935, he made two brief visits to Kansas in March and May 1936 as part of his first extended photographic trip, very early in the life of the agency. His eighty-nine surviving photographs of Kansas, twenty-six of which are reproduced here, were part of a larger assignment to document the impact of dust bowl conditions in the West. In April 1936, Stryker wrote to him in Texas instructing him to "pick up a few more . . . scenes including such things as the dust blown up over barns and fields and crops covered with dust" as he traveled north. He also warned Rothstein about taking better care of his cameras in that dust—a precaution that must have been difficult to follow because in May, Stryker wrote to Rothstein complaining about scratches in the negatives that he had sent to Washington.[*]

In western Kansas—near Liberal and Dodge City—Rothstein had already found plenty of shifting drifts of dust in March 1936. Returning two months later, traveling from Kansas City (where he photographed the stockyards), Rothstein recorded the accomplishments of a number of RA rehabilitation projects in Cherokee, Jefferson, Franklin, Shawnee, Douglas, and Columbus Counties. Ironically, his stark portrait "Bank That Failed" [p. 47], one of the few Farm Security Administration photographic images of Kansas to be widely reproduced, is not identified by either time or place.

In 1940, Rothstein left the FSA to work for *Look;* he later served as the photographic editor of *Parade.*

[*]Roy Stryker to Arthur Rothstein, 13 April and 12 May 1936, *Stryker Papers.*

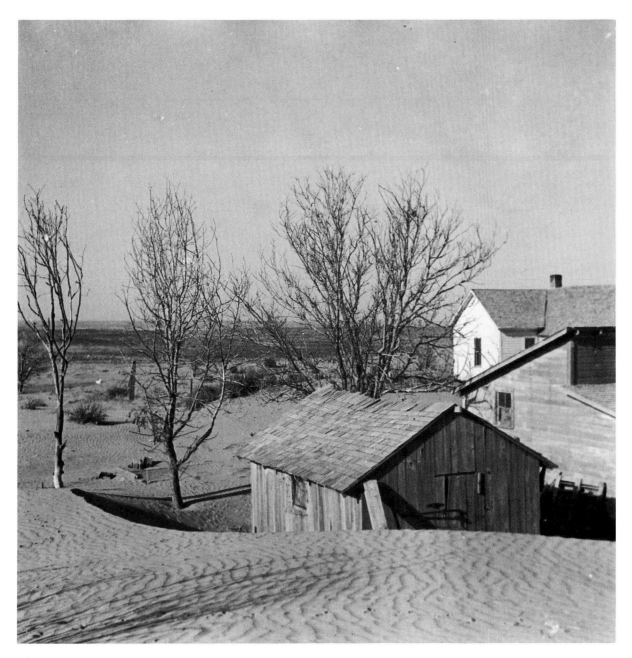

March 1936, Liberal vicinity.

Soil blown by dust bowl winds piled up in large drifts on a farm.

LC-USF34-2504-E

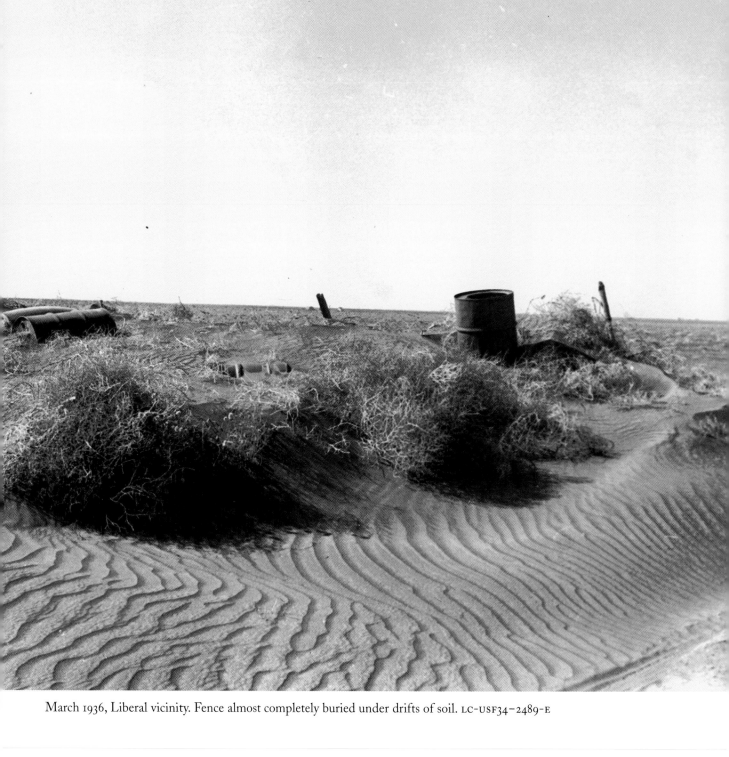

March 1936, Liberal vicinity. Fence almost completely buried under drifts of soil. LC-USF34-2489-E

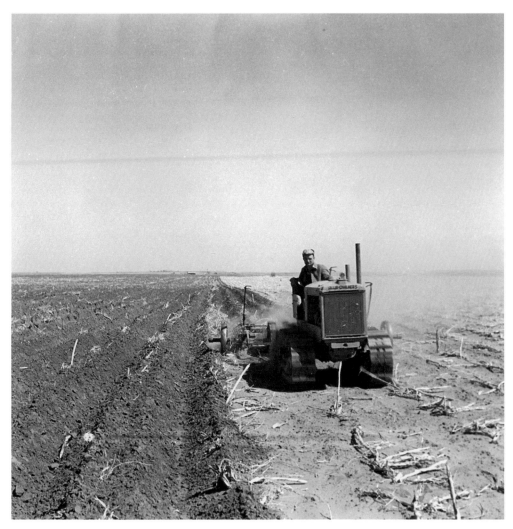

March 1936, Liberal vicinity. A farmer listing his fields under the wind erosion control program. He receives 20 cents an acre for the work. LC-USF34-2493-E

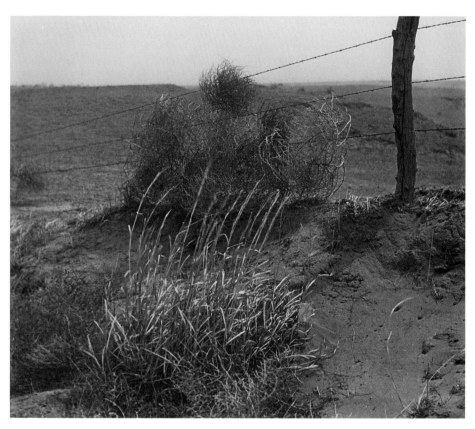

March 1936, Ford County. Tumbleweeds caught on a barbed wire fence. LC-USF34–1872-E

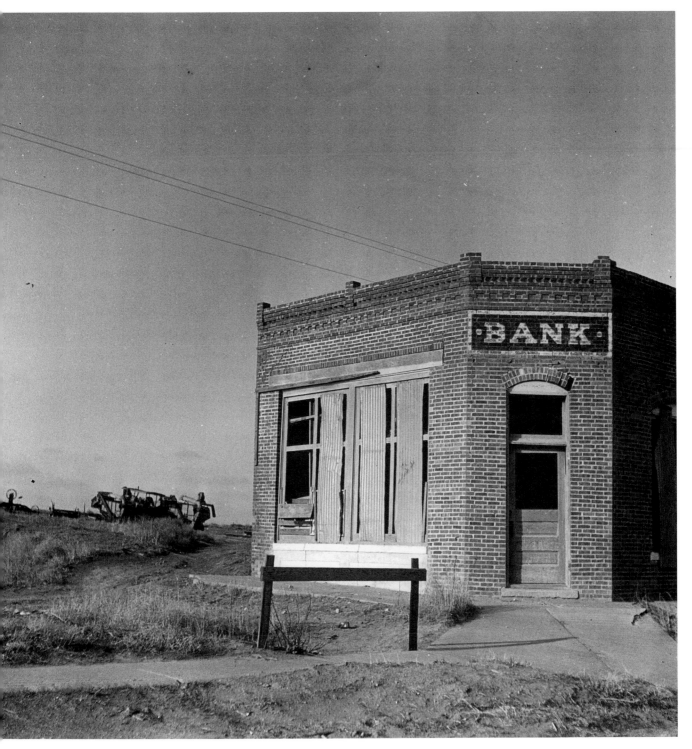

March 1936, Kansas. Bank that failed. LC-USF34–4223-E

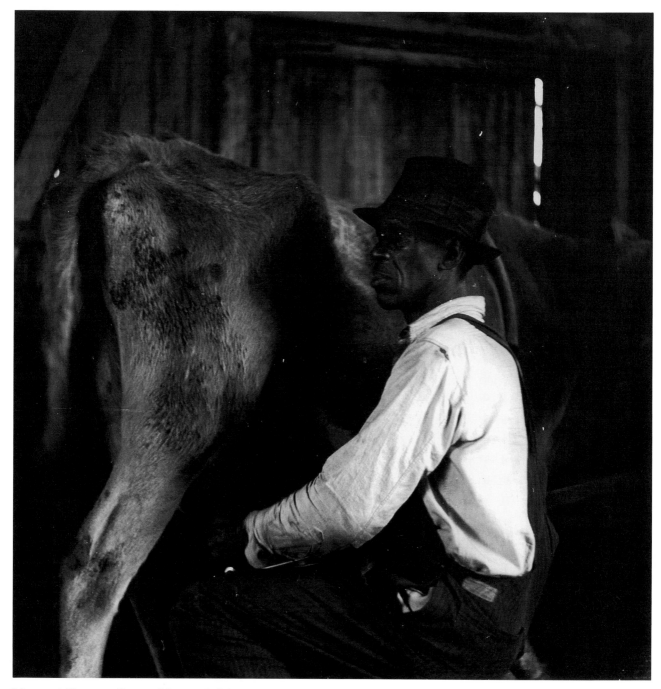

May 1936, Shawnee County. Negro rehabilitation client. LC-USF34–4218-E

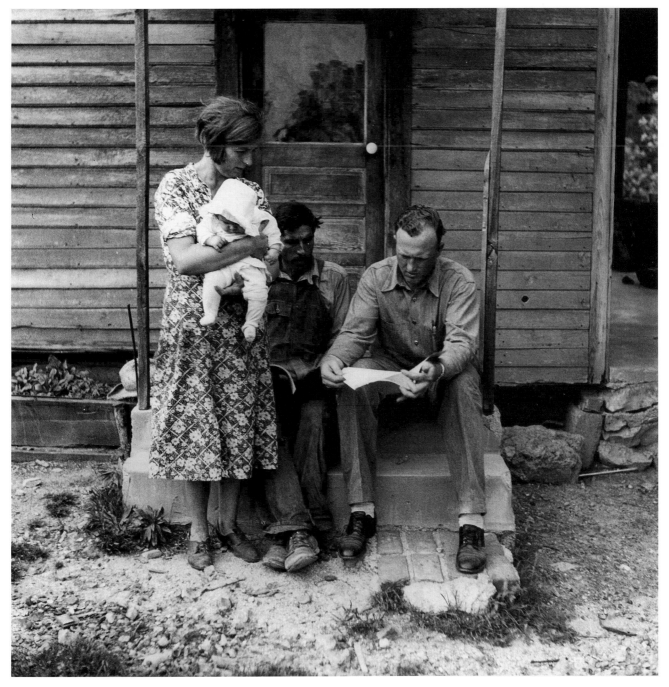

May 1936, Cherokee County. Talking over the farm plan with the county supervisor. LC-USF34-4240-E

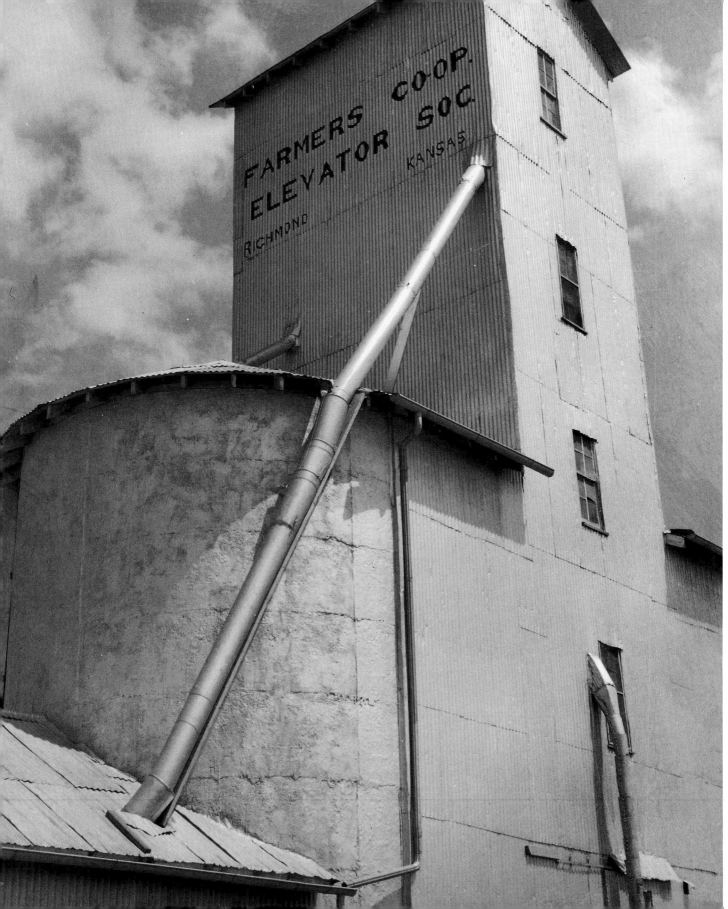

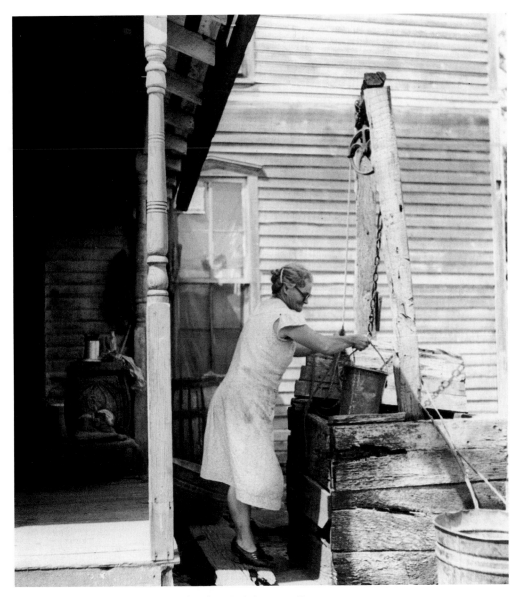

May 1936, Cherokee County. Wife of a rehabilitation client. LC-USF34−4241-E

May 1936, Richmond. Farmer's cooperative grain elevator. LC-USF34-RA-4270-D

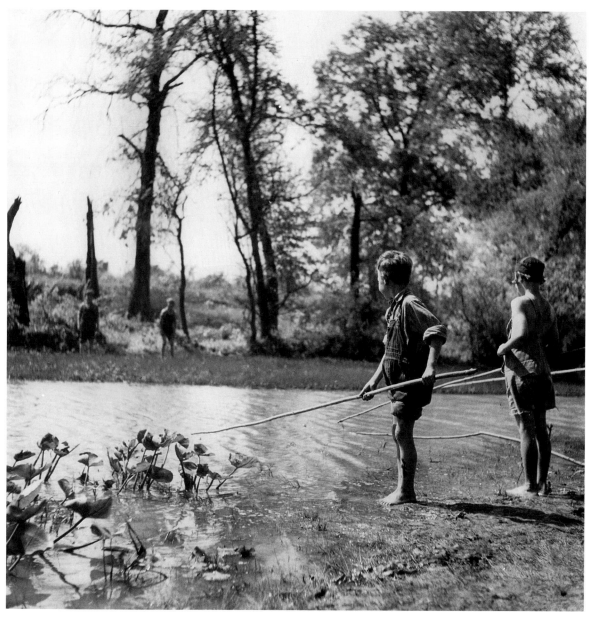

May 1936, Cherokee County. Rehabilitation clients' children fishing in a creek. LC-USF34–4178-E

May 1936, Jefferson County. Son of a rehabilitation client. LC-USF34–4221-E

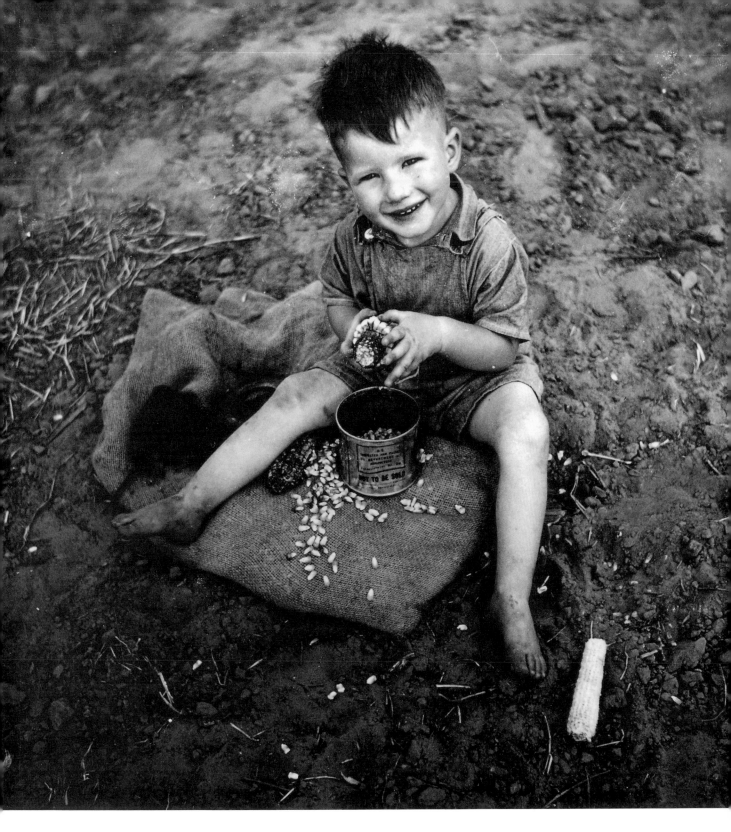

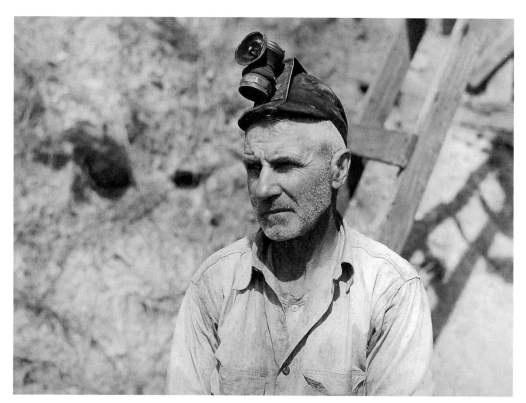

May 1936, Cherokee County. Coal miner. LC-USF34-4171-D

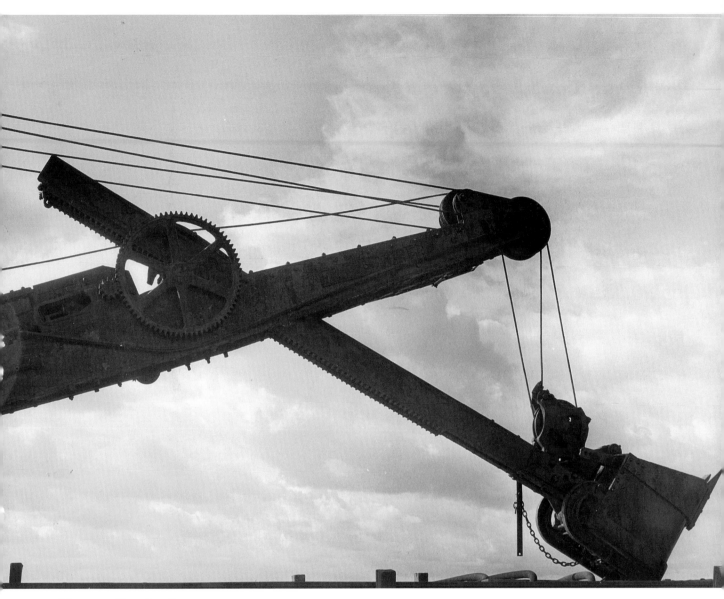

May 1936, Cherokee County.

Steam shovels ruin good farm land in strip mining operations.

LC-USF34-4271-D

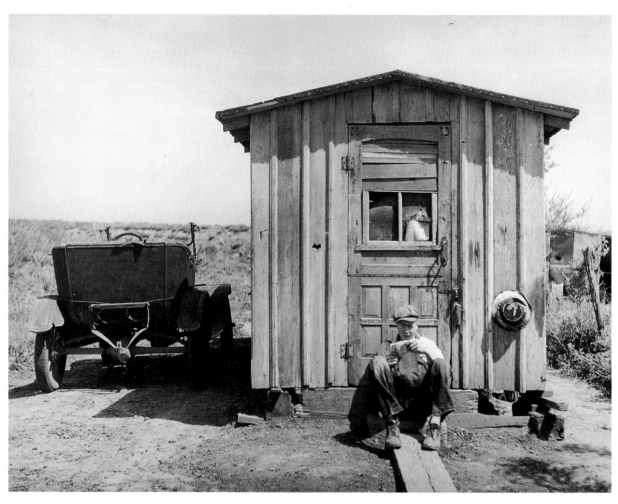

May 1936, Cherokee County. Home of worker in strip coal mine. LC-USF34-4119-D

May 1936, Galena. Unemployed miners. LC-USF34-4141-E

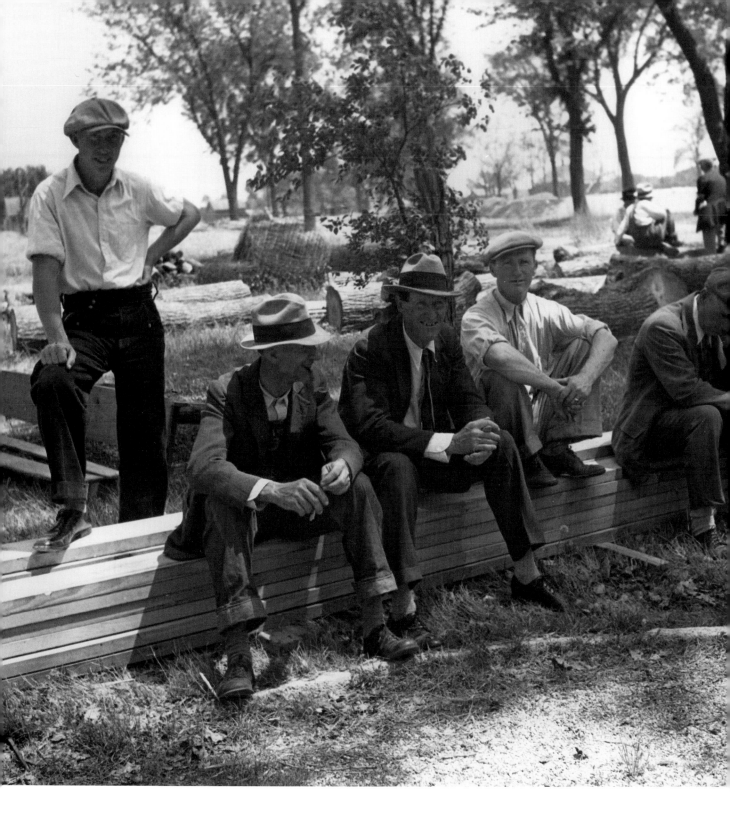

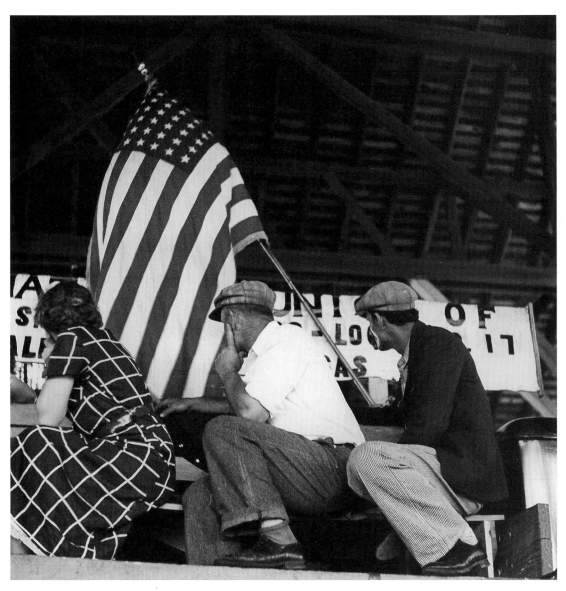

May 1936, Cherokee County. Striking zinc miners. LC-USF34-4179-E

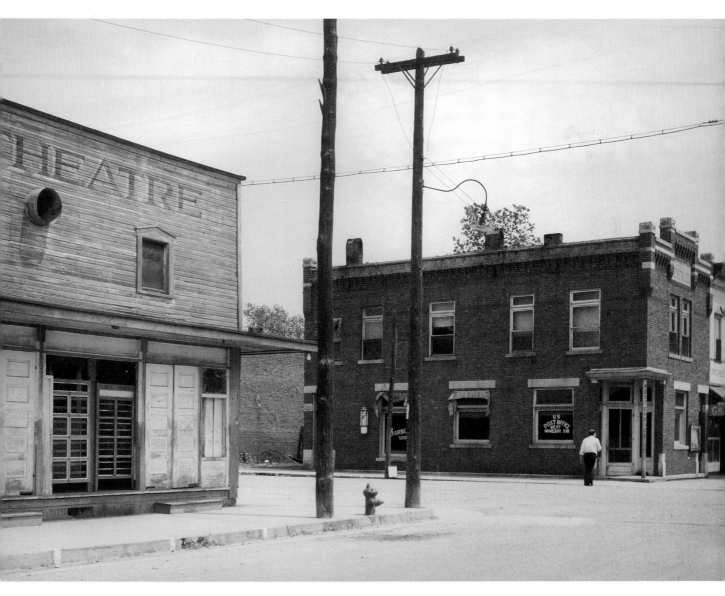

May 1936, West Mineral. An almost deserted mining town. LC-USF34-4273-D

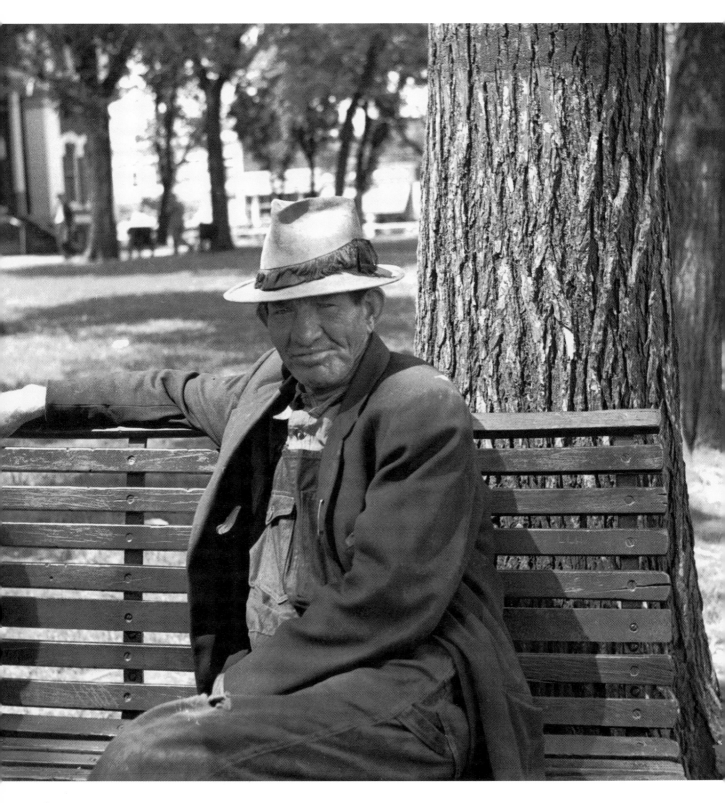

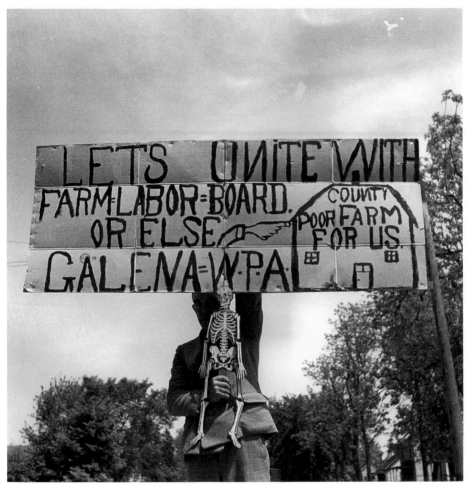

N.d., Cherokee County. Farmer laborite in a demonstration. LC-USF34–4177-E

May 1936, Columbus. Zinc smelter worker who has turned to farming while out of work. LC-USF34–4233-E

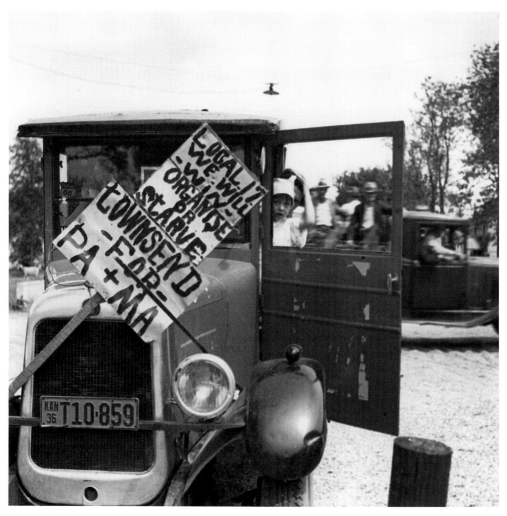

May 1936, Columbus. Townsend Plan supporter. LC-USF34-4168-E

May 1936, Columbus. Wives of farmer laborites. LC-USF34-4165-E

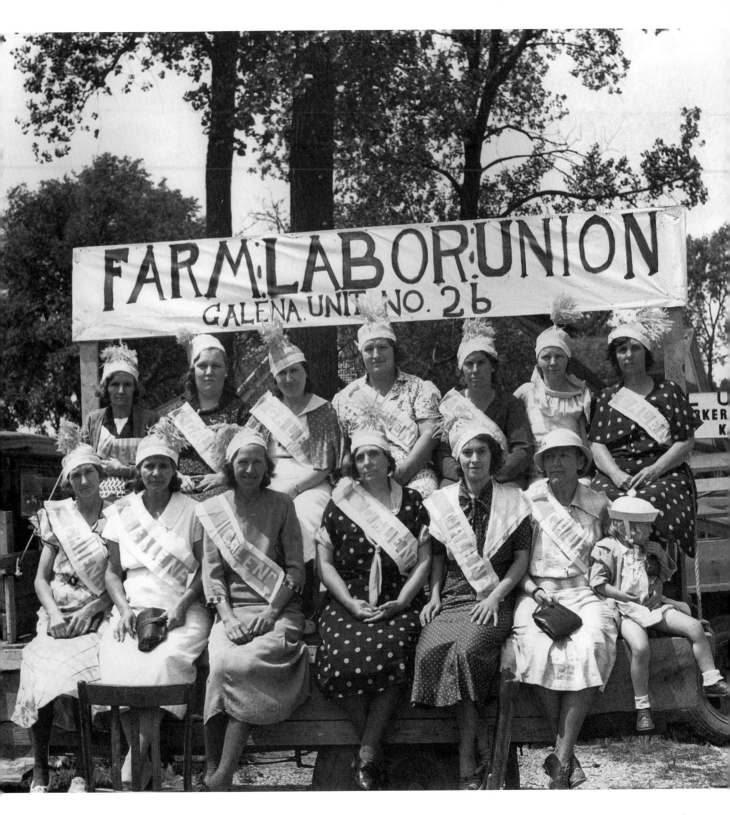

May 1936, Columbus. County courthouse. LC-USF34-4225-E

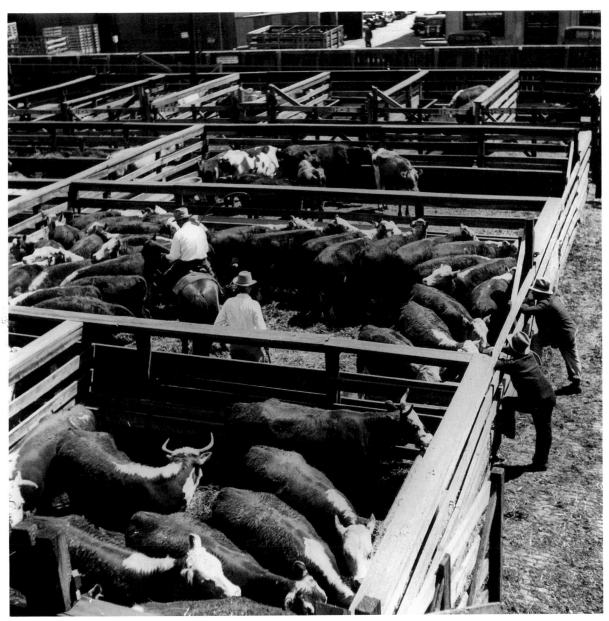

May 1936, Kansas City. Inspecting cattle in the stockyards. LC–USF34–4206–E

May 1936, Kansas City. Drovers' hotel opposite the stockyards. LC-USF34-4213-E

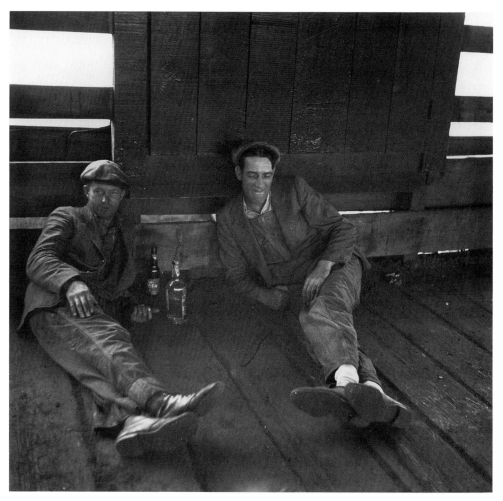

May 1936, Kansas City. Drovers at rest in the stockyards. LC-USF34-4211-E

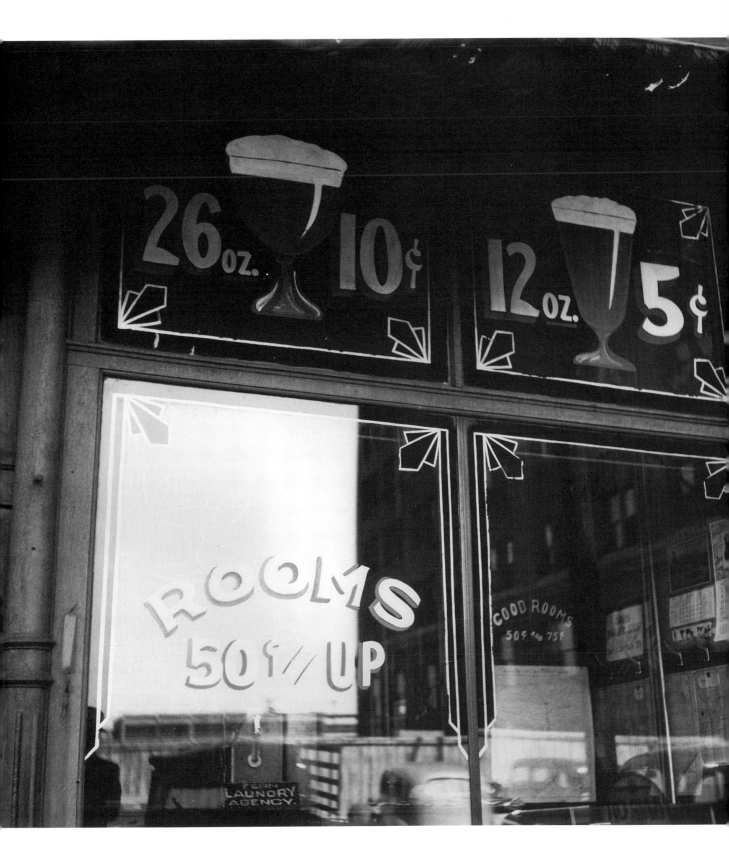

May 1936, Kansas City. Flour mill. LC-USF34–4214-E

JOHN VACHON

John Vachon (1914–1975) was born in St. Paul, Minnesota. An unemployed recent graduate of Catholic University in Washington D.C., he joined the Historical Section of the Resettlement Administration in May 1936 as an assistant messenger. Initially uninterested and untrained in photography, for a year he captioned photographs at staff headquarters, gaining an appreciation of the visual styles of the photographers whose images he handled daily. A chance remark he made to Roy Stryker in the spring of 1937 led to his first photographic assignment—to record street-corner scenes in Washington. Soon thereafter, Walker Evans and Arthur Rothstein took a hand in Vachon's photographic education, introducing him to professional cameras and instructing him in visual techniques.

The month-long trip to Kansas and Nebraska that Vachon made in October and November 1938 was the former file clerk's first extended photographic trip for the Farm Security Administration. Traveling by train and bus, he met with a series of local county supervisors to document the work they had accomplished with their rehabilitation clients in and around Salina, Baldwin City, Oskaloosa, and Centralia. The enthusiastic and eager twenty-four-year-old wrote back to Washington, "I've really become sold on the rehabilitation program. For the first time I see that it is the fundamental and important part of FSA, and that county supervisors are in general pretty good guys, doing good jobs."* That trip to the Great Plains marked a turning point in Vachon's career, for during his travels he discovered his own vision and style. Of the forty-six photographs of Kansas he took in the autumn of 1938 that remain in the FSA files, twelve are reproduced here.

In 1940, Vachon became an official staff photographer for the FSA. He moved to the Office of War Information with the Historical Section, and later followed Stryker to New York to work for Standard Oil until he was drafted into the army in 1944. After the war, he worked again briefly for the SONJ project, leaving in 1948 to become a photographer for *Look*.

*John Vachon to Roy Stryker, "Sun. Morning from Lincoln" [October 1938], *Stryker Papers.*

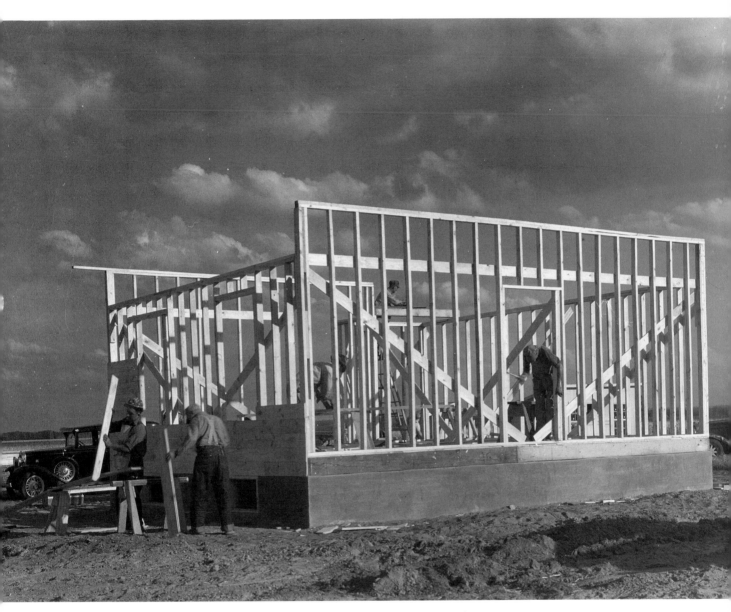

October 1938. Building a new house on the northeast Kansas development project. LC-USF34-8744-D

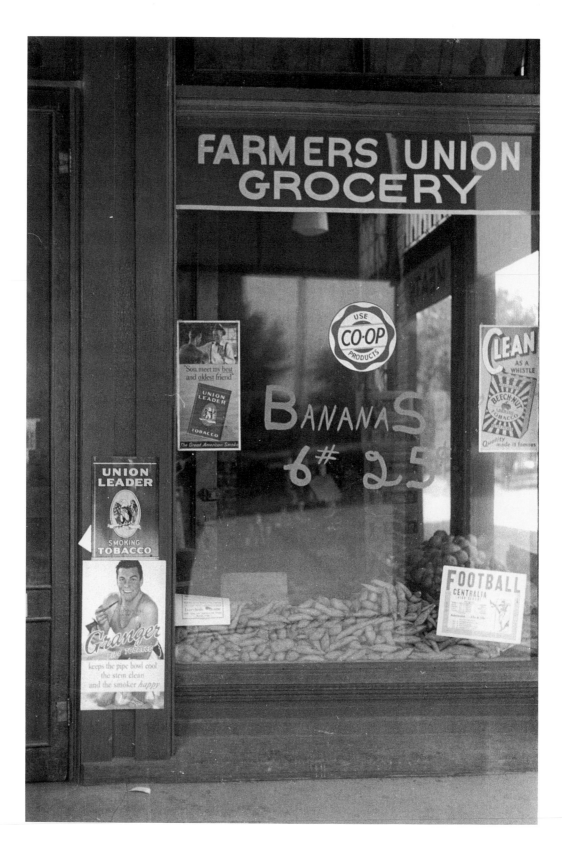

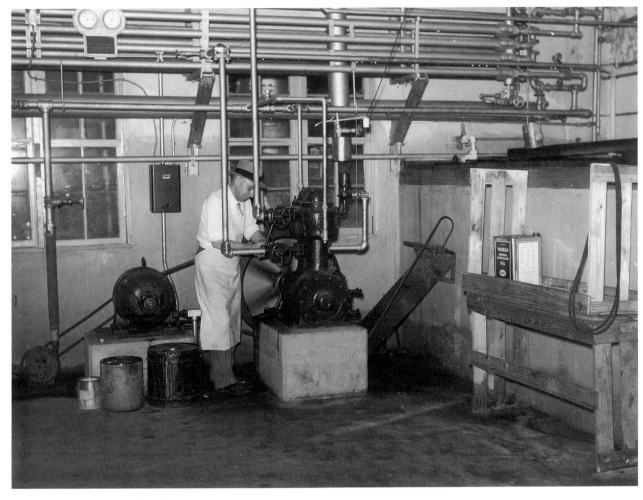

October 1938, Baldwin City. Cooling system in the cooperative creamery. LC-USF34–8751-D

October 1938, Centralia. Farmers' union cooperative grocery store.
This cooperative has received a loan from FSA. LC-USF33–1239-MI

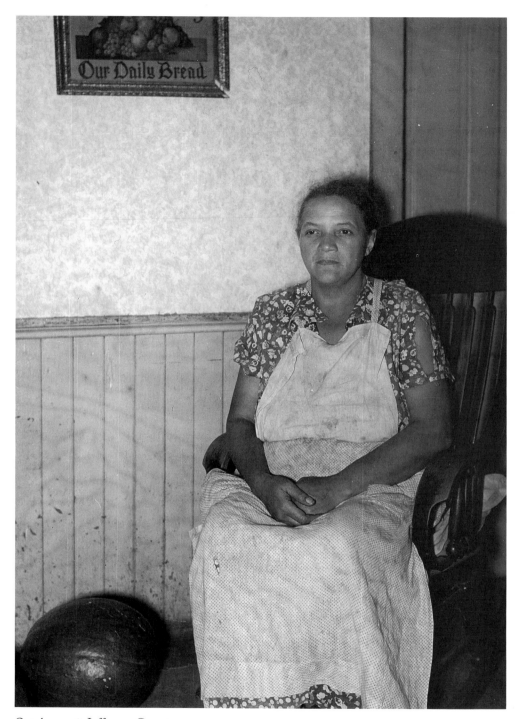

October 1938, Jefferson County.

Wife of a Negro tenant farmer, who is a rehabilitation client.

LC-USF34-8722-D

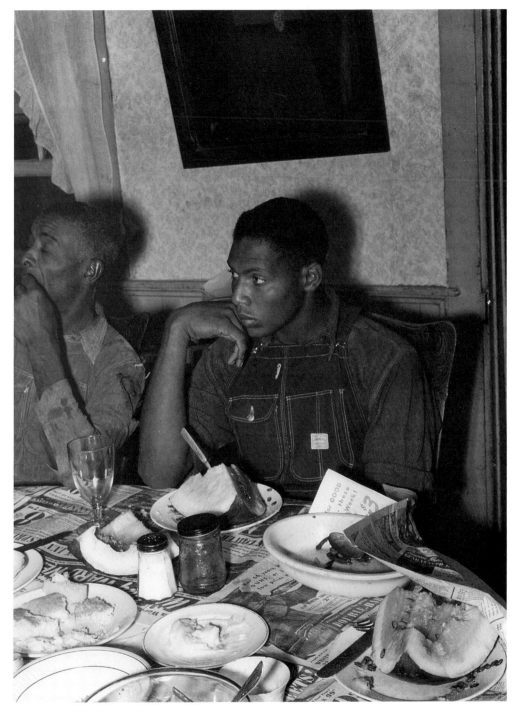

October 1938, Jefferson County.

Son of a Negro tenant farmer, who is a rehabilitation client.

LC-USF34–8673-D

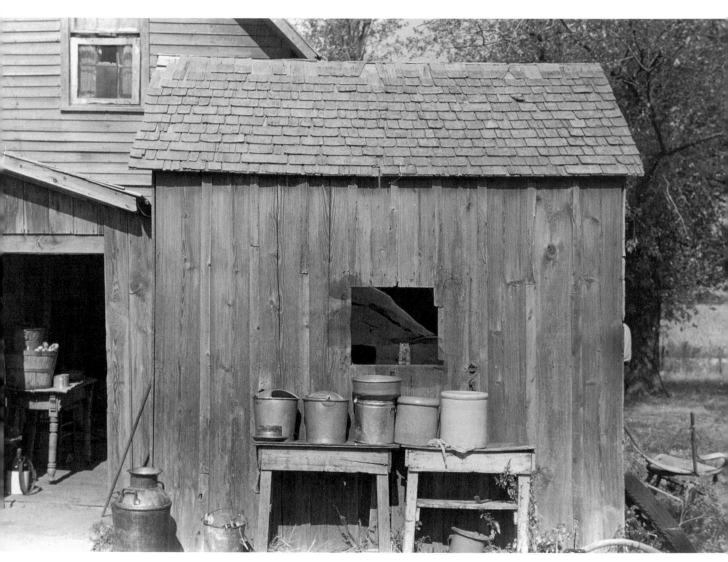

October 1938. Rear of a Negro tenant farmer's home in Kansas. LC-USF33–1253-M2

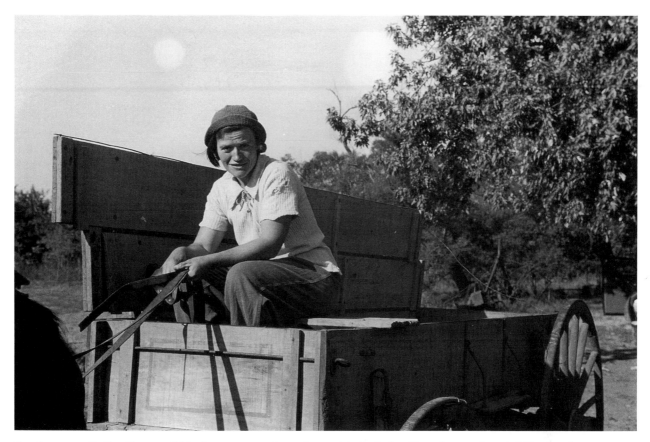

October 1938, Coffey County. Girl who operates a large farm with the help of her sister and a rehabilitation loan.

LC-USF33-1233-M5

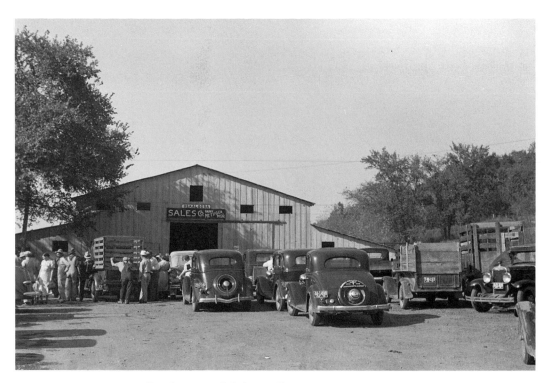

October 1938, Oskaloosa. Farmers waiting for the auction to begin.

LC-USF33-1250-M5

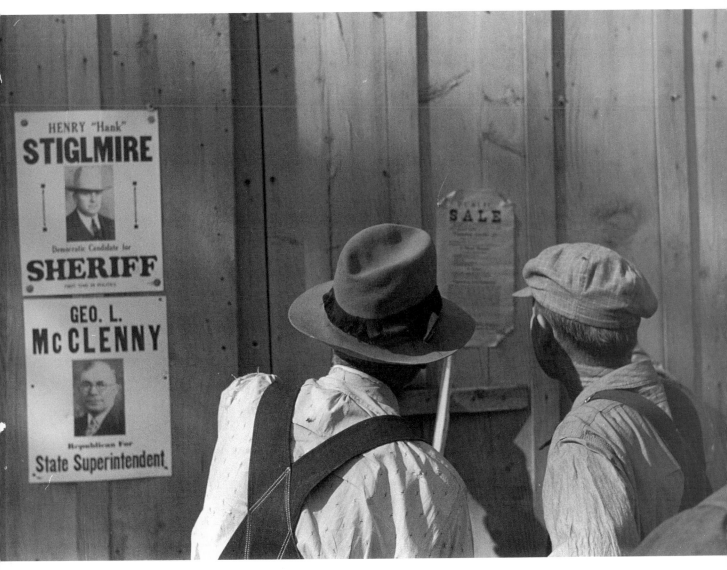

October 1938, Oskaloosa. Farmers waiting for an auction to begin. LC–USF33–1250–MI

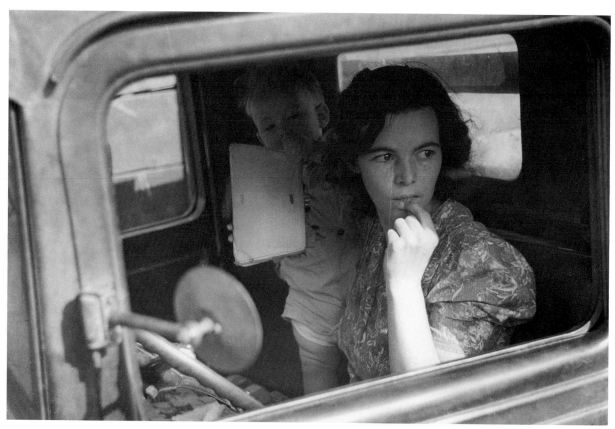

October 1938, Oskaloosa.

Farm wife waiting in the car while her husband attends the auction.

LC-USF33-1273-M3

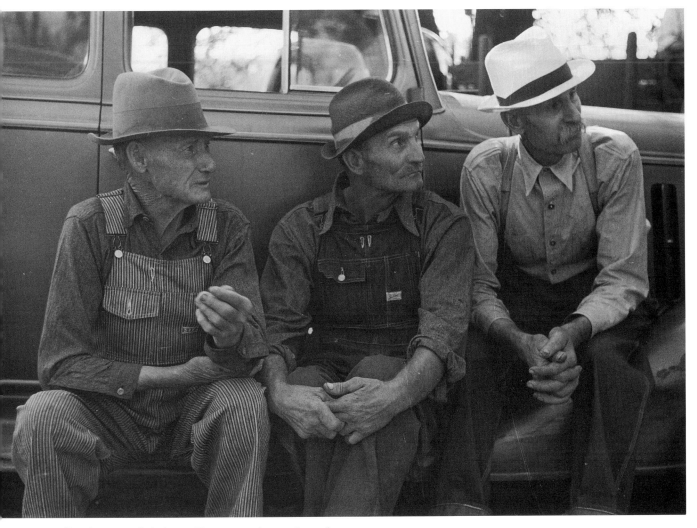

October 1938, Oskaloosa. Farmers at the auction sale. LC-USF33–1272-M3

October 1938, Oskaloosa. Farm wives at an auction. LC-USF33-1272-M5

RUSSELL LEE

Russell Lee (1903–1986) was brought up in the small town of Ottawa, Illinois; he graduated from Lehigh University and worked for several years as a chemical engineer before buying his first camera in 1935. He heard of the photographic work of the Historical Section staff of the Resettlement Administration and traveled to Washington to meet Roy Stryker in the summer of 1936; he was hired in September. Lee spent most of the next six and a half years, before he joined the Air Force in early 1942, on the road for the section, often traveling for months at a time. He insisted on processing his own film and perfected a system of working in the field for three or four days and then retiring to a comfortable hotel where his bathroom became a temporary darkroom.

By the time he went to Kansas in August and September 1939, Lee was a veteran of the Farm Security Administration. He and his second wife, Jean, whom he met while on assignment for Stryker in New Orleans in 1938, often traveled together, and they pioneered and perfected the FSA small-town portraits. In the summer of 1939, the Lees and Arthur Rothstein had been sent west separately to shoot images for a photographic essay illustrating the Oklahoma side of the migrant-worker story of John Steinbeck's *Grapes of Wrath* (1939), for which Dorothea Lange had provided such vivid images from California. When Stryker met Lee in Oklahoma in August to confer in the field, he decided to send Lee next to Kansas. Although the original plan had been to take shots of the wheat harvest and oil fields, Lee was reassigned to photograph the hardworking families of a number of FSA rehabilitation-program clients in Sheridan and Gray Counties.[*] Near Cimarron and Syracuse, he documented the continuing desolation of the great dust storms, photographing abandoned farms that further underscored the dust bowl devastation featured in the Oklahoma *Grapes of Wrath* series.

Most of Lee's 124 Kansas photographs were of people, however. The small photographic essay of the 4-H Club fair in Cimarron in August 1939 [pp. 103–6] shows him at his best. Lee also photographed a similar fair in Sublette a month later [p. 107]. These fairs, he explained in his captions, were yet another illustration of the effects of the drought: the financial requirements of a county fair were beyond the means of most counties and communities, and the much smaller 4-H Club fairs had supplanted them in the western sections of the state.

After the war, Lee worked on a series of "Picture Story" assignments for Stryker

[*]Russell Lee to Roy Stryker, 22 June 1939; Stryker [telegram and letter] to Lee, 26 July 1939; Stryker to Lee, 1 September 1939; Lee to Stryker, 2 September 1939, *Stryker Papers.*

83

and Standard Oil. From 1948 to 1961, he was first a photographer for and then the director of the University of Missouri Photo Workshop. From 1965 to 1974, he was a faculty member in the Fine Arts Department at the University of Texas.

August 1939, Sheridan County. FSA supervisor explaining farm plans to clients. LC-USF34-34095-D

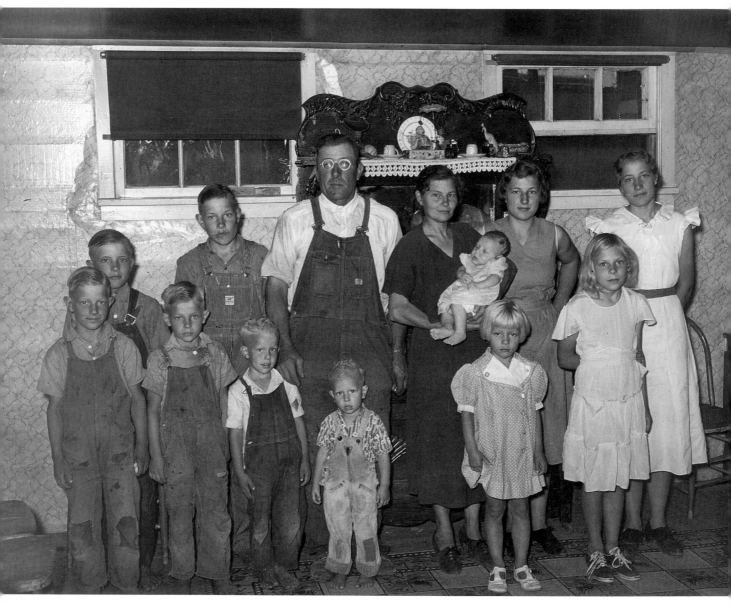

August 1939, Sheridan County. Family of William Rall, an FSA client. LC-USF34–34084-D

August 1939, Sheridan County. Mr. Germeroth, an FSA client, at the wheel of a tractor which he bought with an FSA loan. LC-USF34–34094-D

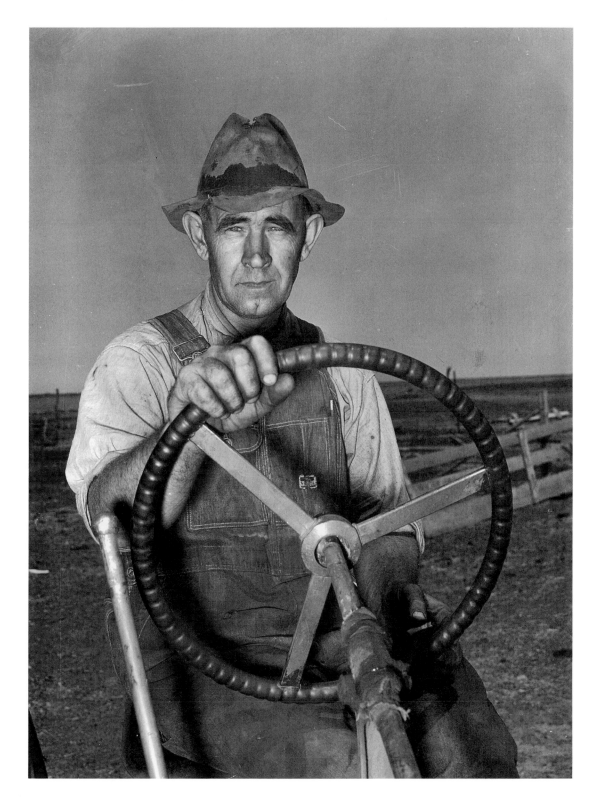

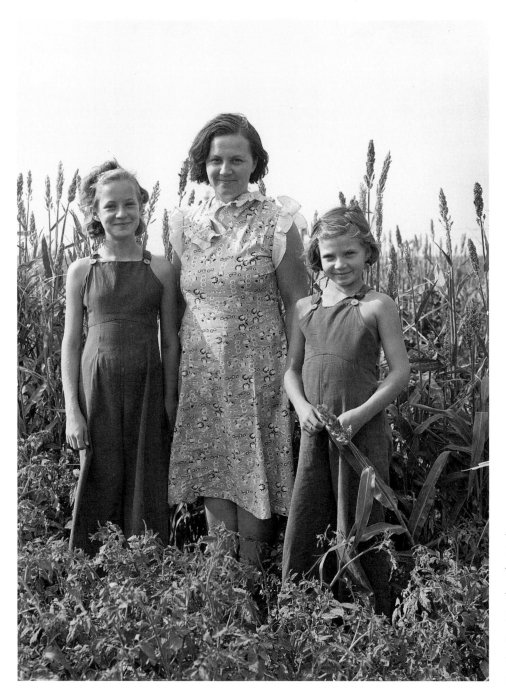

August 1939,
Sheridan County.
Wife of an FSA client
with her two children
in the garden. Kaffir
corn in background is
used as a windbreak.

LC-USF34–34111-D

August 1939, Sheridan County. Trench silo. LC-USF34–34108-D

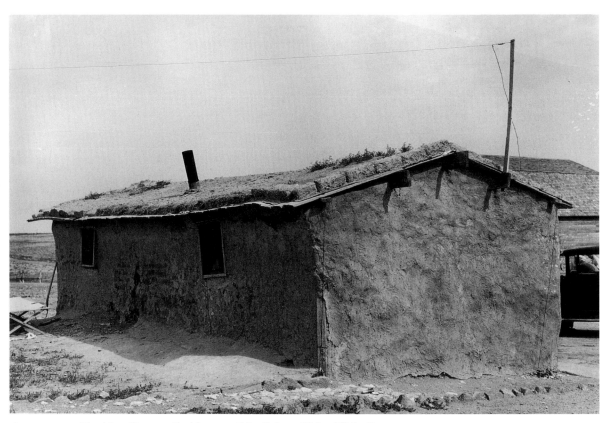

August 1939, Sheridan County. Sod house of the Schoenfeldts, FSA clients. LC-USF34–34112-D

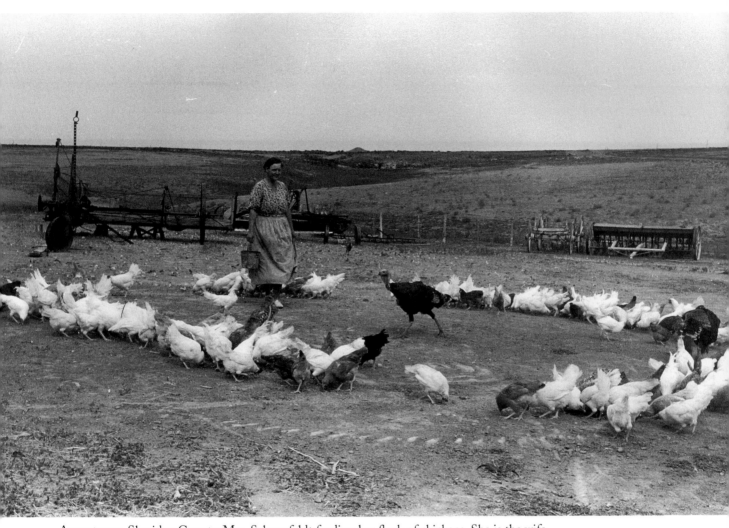

August 1939, Sheridan County. Mrs. Schoenfeldt feeding her flock of chickens. She is the wife of an FSA client. LC-USF33–12357-M4

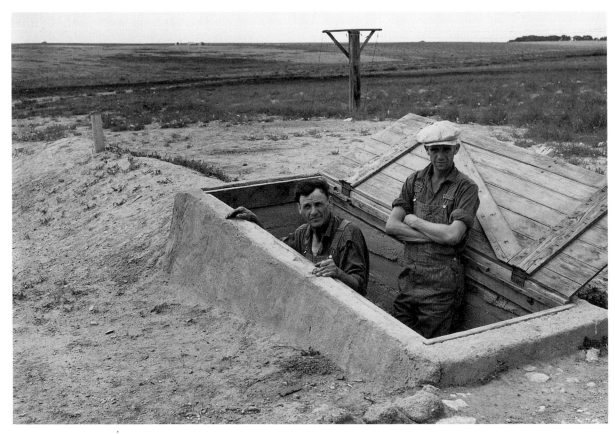

August 1939, Sheridan County. Mr. Schoenfeldt and son, FSA clients, at entrance to fruit cellar which they built for $6.20. LC-USF34–34086-D

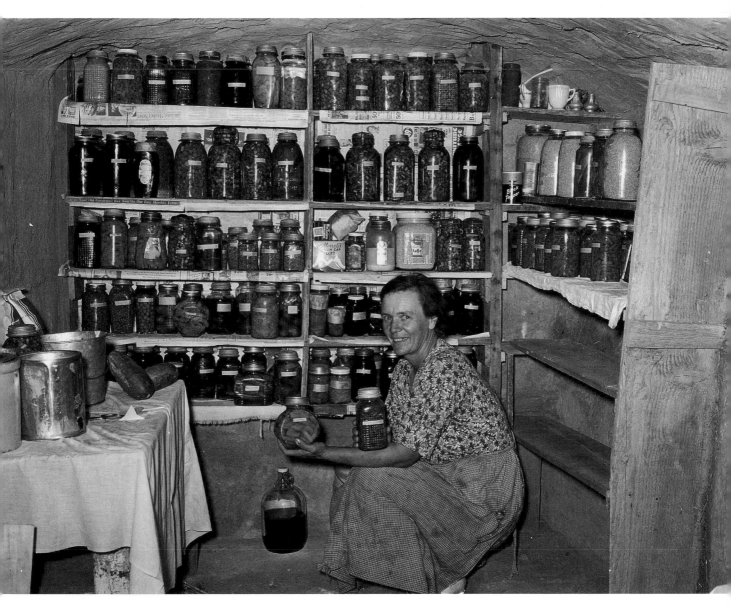

August 1939, Sheridan County. Mrs. Schoenfeldt, an FSA client, in her fruit cellar. LC-USF34–34089-D

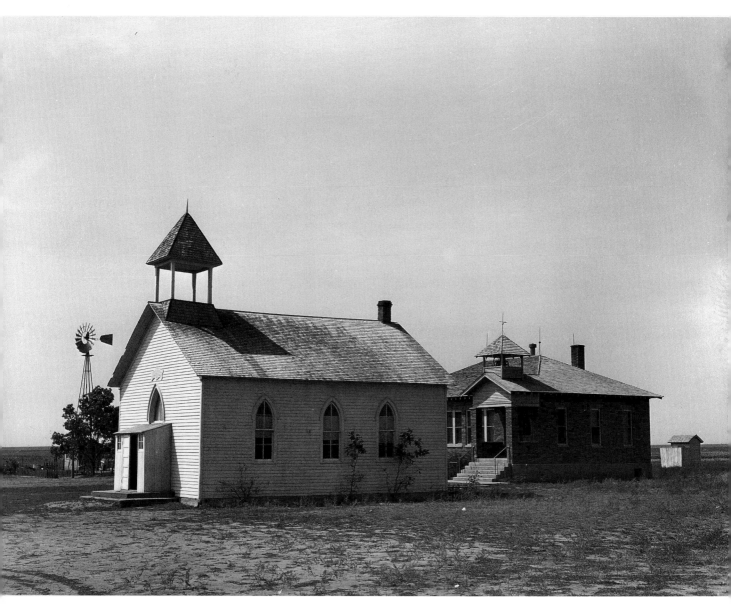

August 1939, Sheridan County. County school and church. LC-USF34-34097-D

August 1939, Gray County. Silo, windmill, and overalls on the line on a farmstead. LC-USF34-34104-D

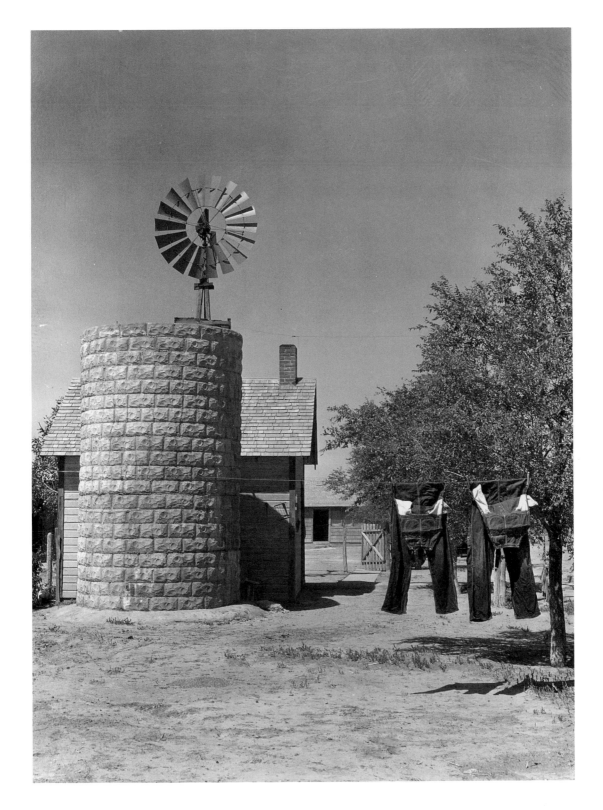

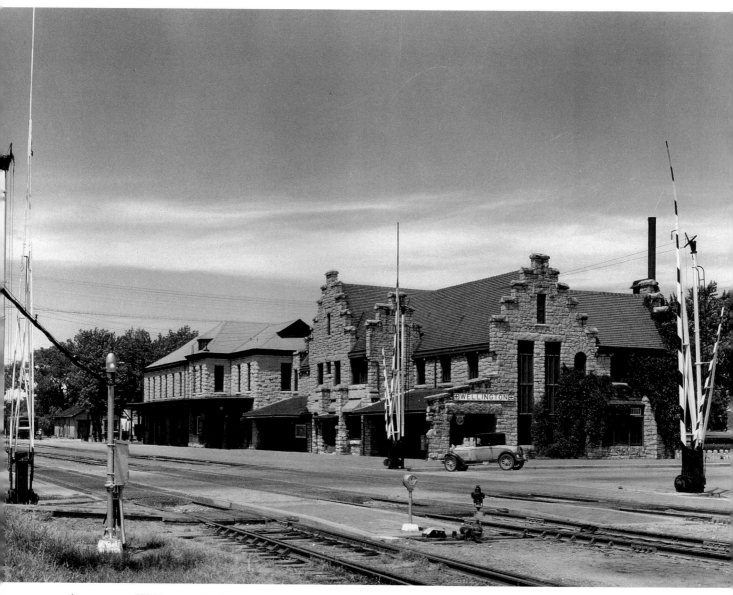

August 1939, Wellington. Railroad station. LC-USF34-34055-D

August 1939, Sheridan County. Farmer digging in the dirt to see how deep the moisture is. LC-USF33-12355-M4

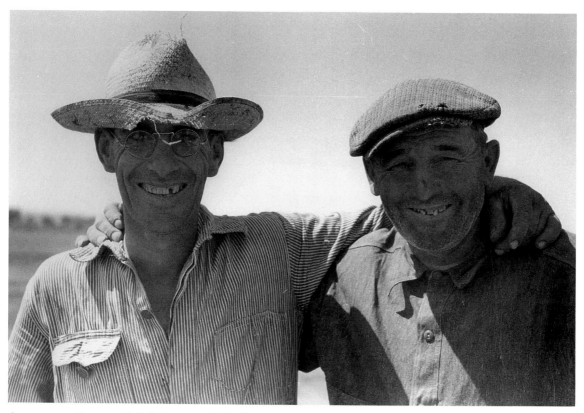

August 1939, Syracuse. Mr. Johnson and Mr. Wright, FSA clients who cooperate in maintaining an irrigation well. LC-USF33-12401-M3

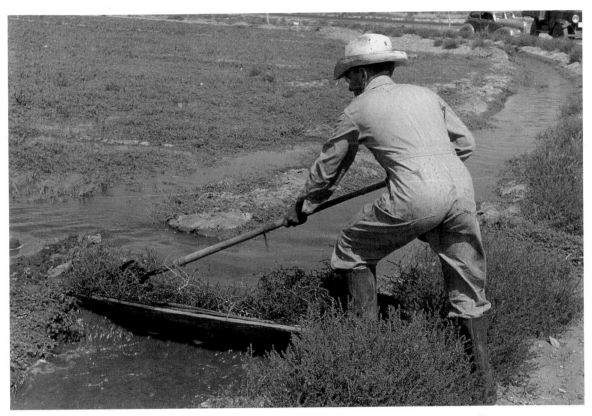

August 1939, Syracuse. Mr. Johnson, an FSA client with a part interest in a cooperation well, irrigating. He has just built a small dam of board and tumbleweed. LC-USF33-12399-M5

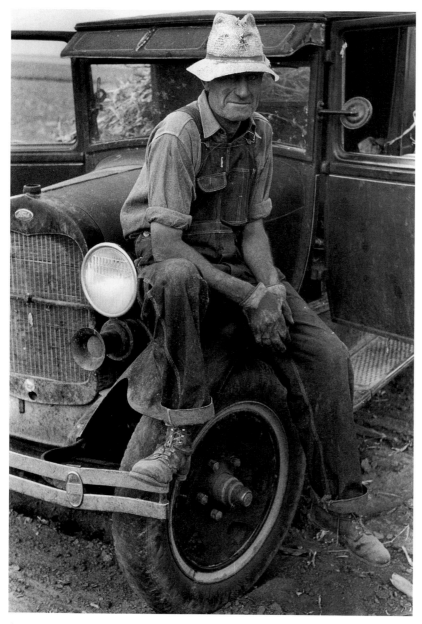

August 1939, Sheridan County. Hired man of a farmer. LC-USF333–12355-M3

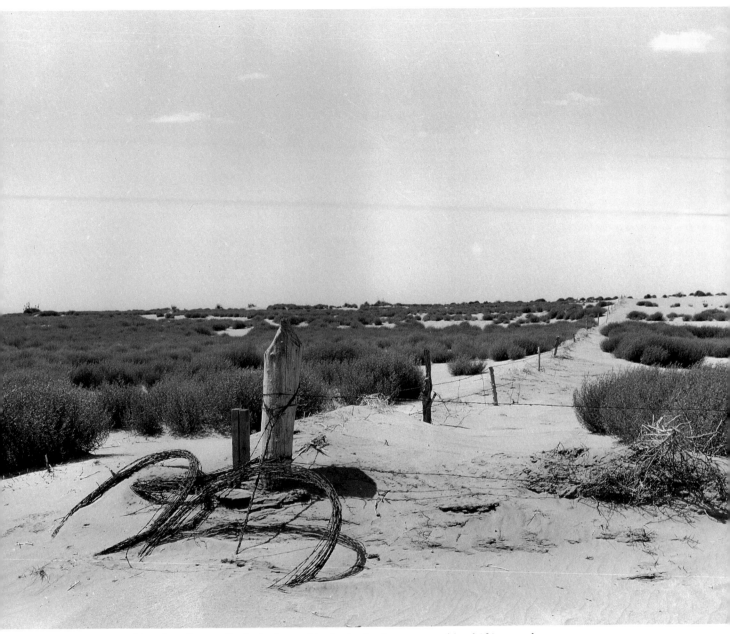

August 1939, Sheridan County. Barbed wire and barbed-wire fence covered by drifting sand with tumbleweed growing up. This is in a section which once produced forty bushels of wheat to the acre. LC-USF34-34167-D

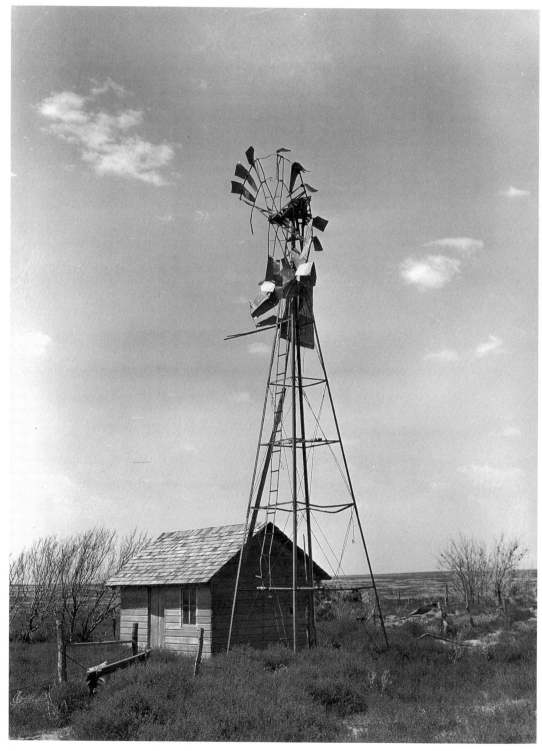

September 1939, Syracuse vicinity. Old windmill and shed on an abandoned farm. LC-USF34–34166-D

August 1939, Cimarron. The 4-H Club fair. Tightrope performers. LC-USF333–12380-M5

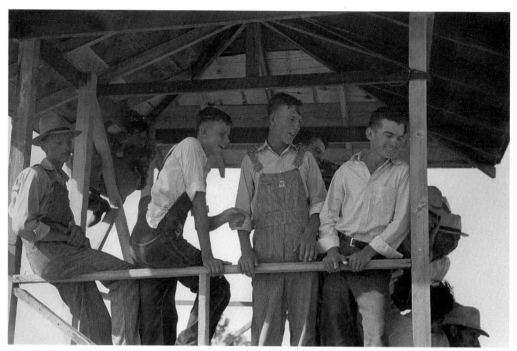

August 1939, Cimarron.

The 4-H Club fair. Boys in the judging stand watching the pie eating contest.

LC-USF33-12379-M4

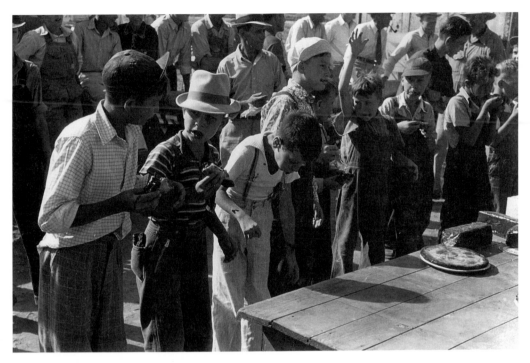

August 1939, Cimarron.

The 4-H Club fair. End of the pie eating contest, winner has his hand raised.

LC-USF33-12379-M1

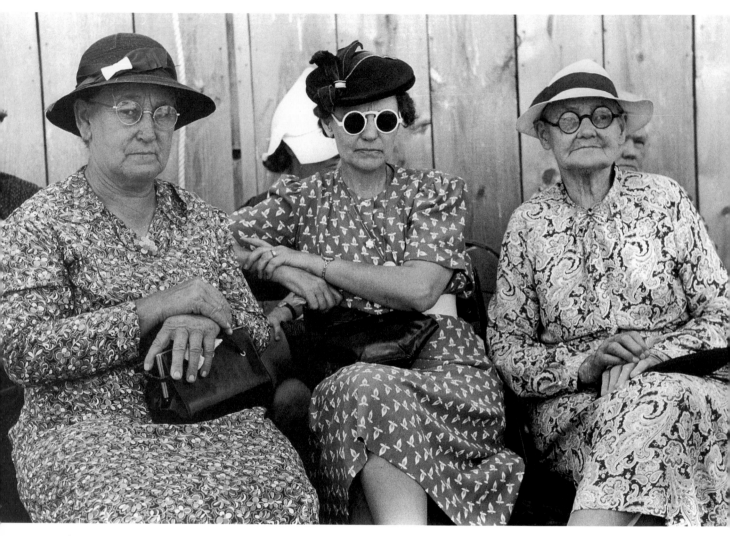

August 1939, Cimarron. The 4-H Club fair. Women at the fair. LC-USF33-12381-M5

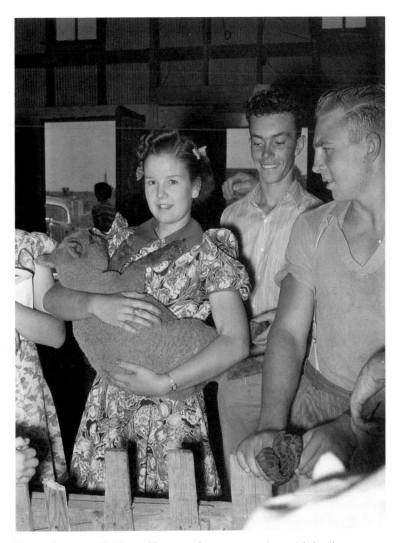

September 1939, Sublette. The 4-H fair. 4-H member with lamb.

LC-USF34-34133-D

UNKNOWN

Most, but not all, of the photographs in the files of the Farm Security Administration and Office of War Information that Roy Stryker transferred to the Library of Congress in 1943 were taken by the photographers of the Historical Section sent into the field by Stryker with specific shooting assignments. A small group of photographs in the file was acquired from other agencies to supplement the section's own visual records. In addition, during 1941 while rural documentation work was decreasing but the section had not yet become part of the OWI within the Office of Emergency Management, Stryker sometimes assigned his photographers under contract on a short-term basis to other agencies to record defense preparations. These two images illustrate the nature of many of those photographs. They are part of a small series documenting the operations of a tent manufacturer in Wichita in June 1941 included by the Library of Congress in its listing of FSA/OWI photographs of Kansas. The identity of the photographer is not known, but the images' intense focus on the faces of individuals at work and the dramatically framed perspective suggest the aesthetic approach of Stryker's photographers at their best.

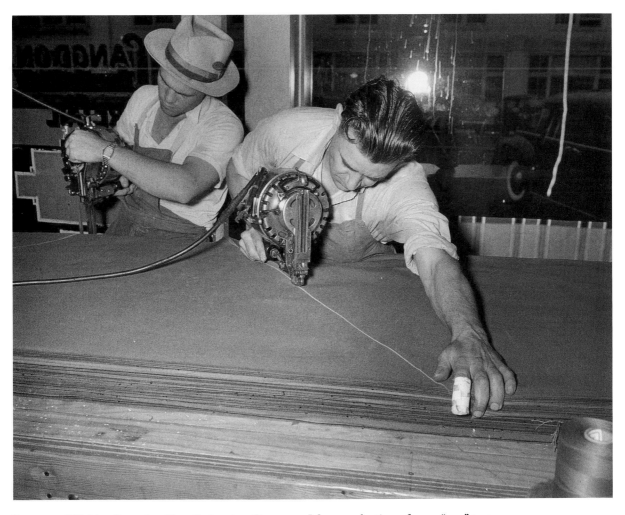

June 1941, Wichita. Langdon Tent & Awning Company. Mass production of 1,500 "pup" tents a day for the expanding defense army. A high-speed cutting machine cuts through 190 layers of cloth at one time. LC-D-1089

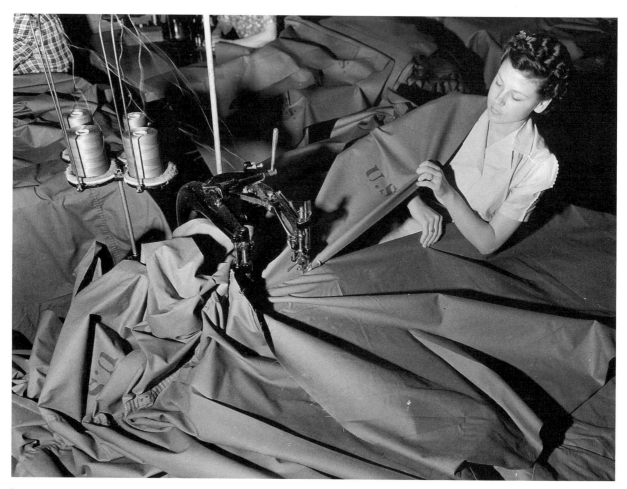

June 1941, Wichita. Langdon Tent & Awning Company. With the grace and dexterity of a master dressmaker this attractive young woman fabricates "pup" tents for the expanding defense army. A two-needle felling machine joins the two widths of cloth to form the main body of the tent. LC-D-1090

MARION POST WOLCOTT

Marion Post Wolcott (1910–1990) was raised in Montclair, New Jersey, and was influenced in her fiercely determined progressive reform convictions by her mother's crusading work for Margaret Sanger to legalize birth control and by her education at the New School for Social Research. Wolcott studied photography in Europe in 1932, and then worked briefly as a freelance photographer and on the staff of the *Philadelphia Evening Bulletin* before Roy Stryker hired her in 1938. Unlike the other woman photographer for the FSA, Dorothea Lange, who often traveled with her economist husband, Paul Taylor, she worked alone until her marriage to Leon Wolcott in June 1941, after a whirlwind courtship. Her trip to the Far West that fall for the Farm Security Administration was their first extended separation; they both found it so painful that Lee Wolcott joined his wife just before Labor Day for a week photographing sheep and cattle ranching in Montana. Shortly after Lee Wolcott left to return east, Stryker assigned Marion Wolcott to travel to Kansas to document the oil fields near Wichita that Russell Lee had originally been sent to photograph two years earlier.

Wolcott took seventy-five photographs in the Kansas oil fields, meticulously recording the details of the defensively strategic process of drilling for oil. Although visually striking, few of her Kansas pictures illustrate her gift for capturing personality on film or her keen eye for photographing children. Perhaps she missed her new husband too much. Within a few months, she resigned from the Historical Section to become a full-time wife and mother. For the next thirty years, her photography was intensely personal, recording her growing family and her travels around the world with her diplomat husband. After the Wolcotts retired to California in 1974, she pursued her photographic activities until her death.[*]

[*]F. Jack Hurley, *Marion Post Wolcott: A Photographic Journey* (Albuquerque: University of New Mexico Press, 1989).

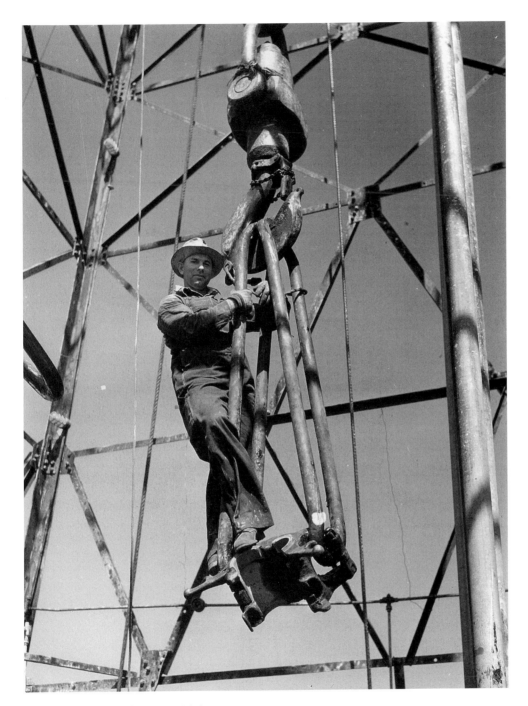

September 1941, McPherson vicinity.

Driller, C. L. Saxton, riding on the traveling block to the top of the oil well derrick
in the C. C. Graber pool of Continental Oil Co. He was originally from Oklahoma
but has been in Kansas for the last six years. LC-USF34–59820-D

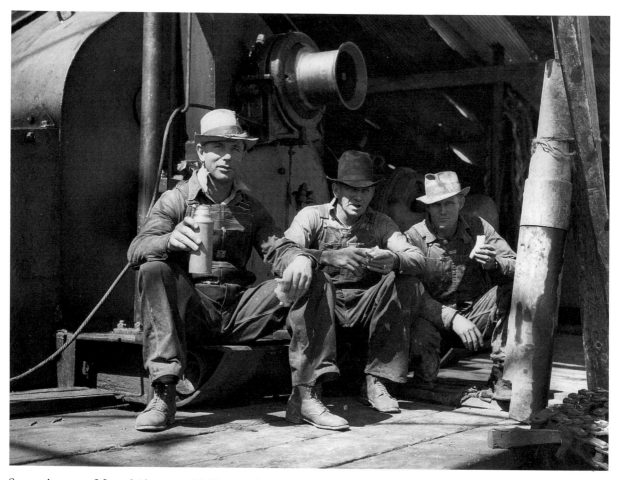

September 1941, Moundridge area, McPherson County. C. L. Saxton, driller, J. G. Betz, cathead man, and L. C. Westerman, eating lunch at an oil well in the C. C. Graber pool of the Continental Oil Co.

LC-USF34-59817-D

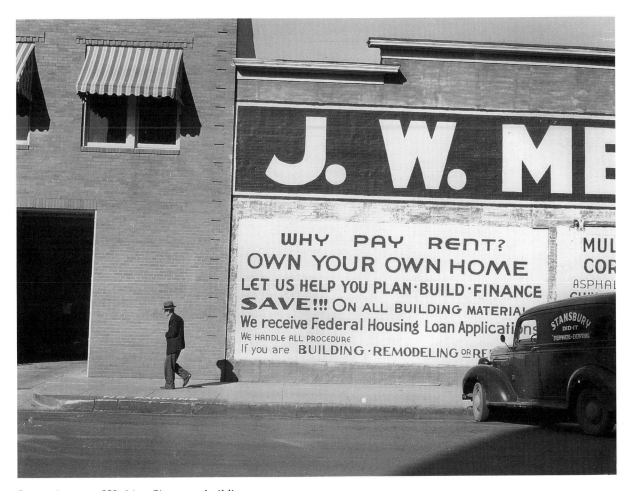

September 1941, Wichita. Sign on a building.

This is a boom town, crowded with new defense workers.

LC-USF34—59835-D

JACK DELANO

Jack Delano was born in Kiev, Russia, in 1914 and emigrated to Philadelphia with his parents while still a boy. A musician before he became a photographer, he studied violin and viola at the Curtis Institute Settlement Music School. The photographer Paul Strand, who had played a key role in introducing Marion Post to Roy Stryker, was impressed by the exhibition in Philadelphia of a photographic project that Delano had completed for the Federal Arts Program. Shortly after Strand brought the young photographer to Stryker's attention, Delano went to work for the Farm Security Administration to replace Arthur Rothstein, who had resigned from the Historical Section in the spring of 1940 to work for *Look*. Just before the bombing of Pearl Harbor, Stryker sent Delano to photograph the Virgin Islands and Puerto Rico, the only FSA documentary work undertaken outside the continental United States. Although there was an FSA office in Puerto Rico, the assignment originated at the request of Governor Charles Harwood of the Virgin Islands, who wanted photographs to accompany a report to Congress. The outbreak of war and the near cessation of all civilian or nonessential air travel nearly stranded Delano and his wife, Irene, in Puerto Rico. Shortly after he returned to Washington, Delano left for the West on a rush assignment to document the army's preparations for war at Camp Funston and Fort Riley. His photographs of black cavalry troops maneuvering and caring for their horses [pp. 121, 122] are a sobering reminder of how quickly and permanently old ways of thinking about military equipment and tactics had to change in the first months of the Second World War. Fortunately for the war effort, the segregated black and white troops at Fort Riley also had opportunities to drill with mechanized equipment. Only a few of Delano's 223 photographs of training men in Kansas for battles in Europe and Africa are reproduced here.

Delano returned to Kansas a year later, in March 1943, on a more extended and, for him, much more satisfying trip. The railroads played a crucial role in the war effort, and in late 1942 Delano had been assigned to the Office of War Information to document the rail industry's heroic response to the unprecedented demands made on rolling stock, repair facilities, rail lines, and crews. He began in Chicago in November 1942, recording the activities of the nation's largest and busiest rail hub. Between March 6 and April 1, 1943, he rode an Atchison, Topeka and Santa Fe train from Chicago to Los Angeles. His route took him through the heart of the Santa Fe's home territory in Kansas. Beginning at the Argentine Yard, just outside Kansas City, he rode the rails through Atchison, Topeka, Emporia, Newton, Wellington, Harper,

and Kiowa. The 129 photographs he made en route provide a vivid set of vignettes of the impact of wartime activities on the home front.

Shortly after returning from his rail journey, Delano was drafted. After the war, he and Irene returned to Puerto Rico, where he was welcomed in 1946 by Governor Rexford G. Tugwell and worked with Edwin and Louise Rosskam in the Division of Community Education. He has remained a resident of the island ever since, working until his retirement for Puerto Rican Educational Television as a filmmaker, director of programming, and general manager. He also taught music at the Puerto Rico Conservatory.[*]

[*]Jack Delano, *Puerto Rico Mio: Four Decades of Change* (Washington: Smithsonian Institution Press, 1990), 21–27.

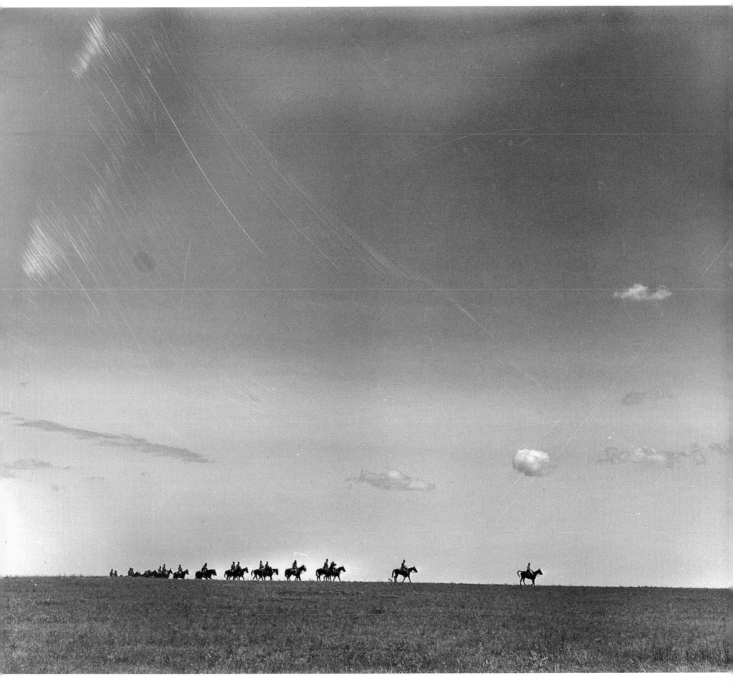

April 1942, Fort Riley. Signal corps message-center set up during a field problem. LC-USW3-4195-D

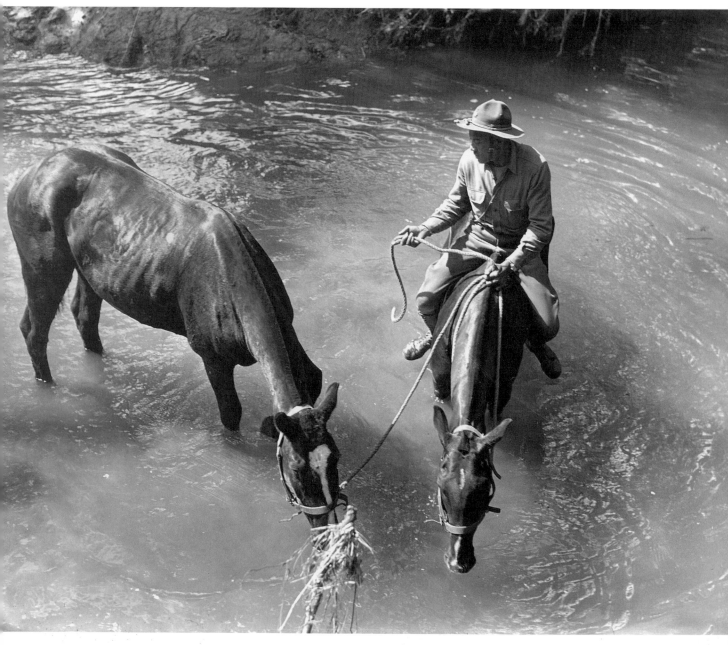

April 1942, Fort Riley. Watering the horses during a field problem of the cavalry. LC-USW3-4176-D

April 1942, Fort Riley.

Soldier of a rifle platoon of a cavalry troop. LC-USW3-4518-D

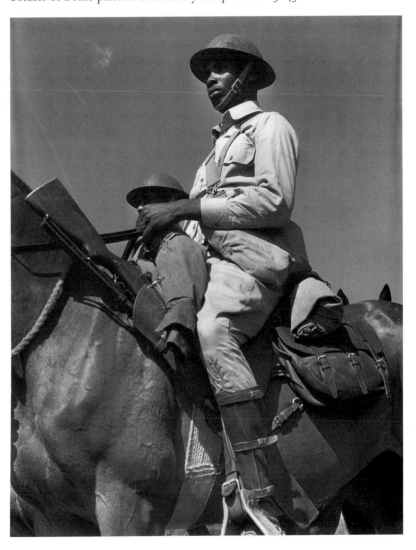

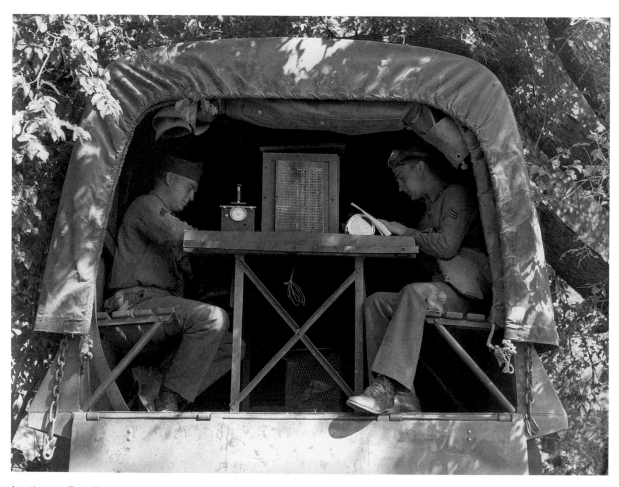

April 1942, Fort Riley. Signal corps message-center set up during a field problem. LC-USW3-4184-D

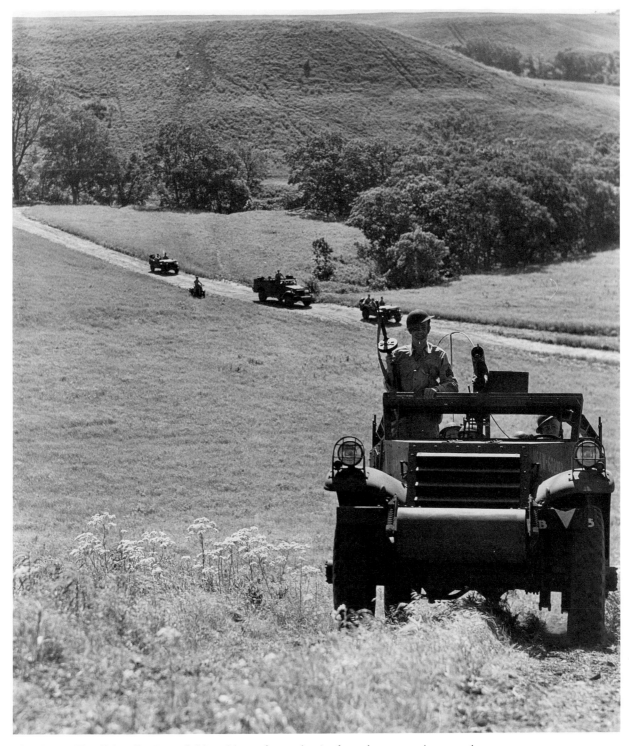

April 1942, Fort Riley. During a field problem of a mechanized cavalry reconnaisance unit. LC–USW3-4274-D

April 1942, Fort Riley.
Motorcyclist of a mechanized cavalry unit manning a machine gun
during a sham battle. LC-USW3-4232-D

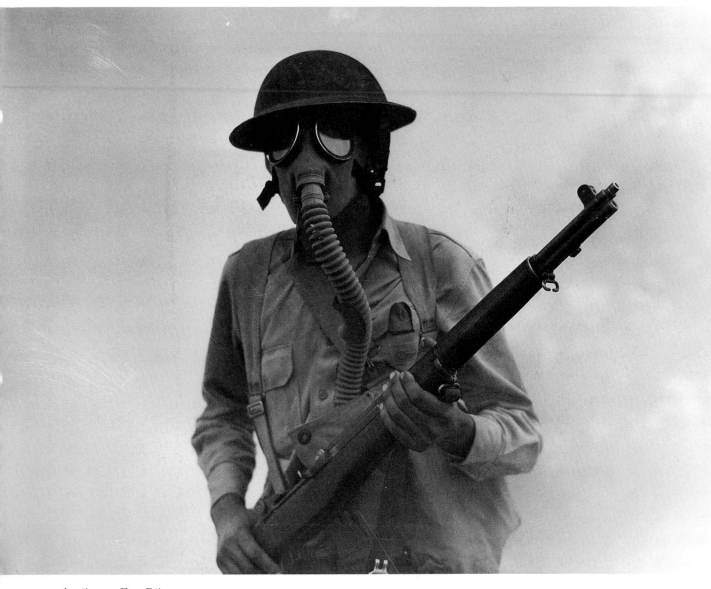

April 1942, Fort Riley.

Soldier of a cavalry rifle unit going through a smoke screen during a field problem.

LC-USW3-4219

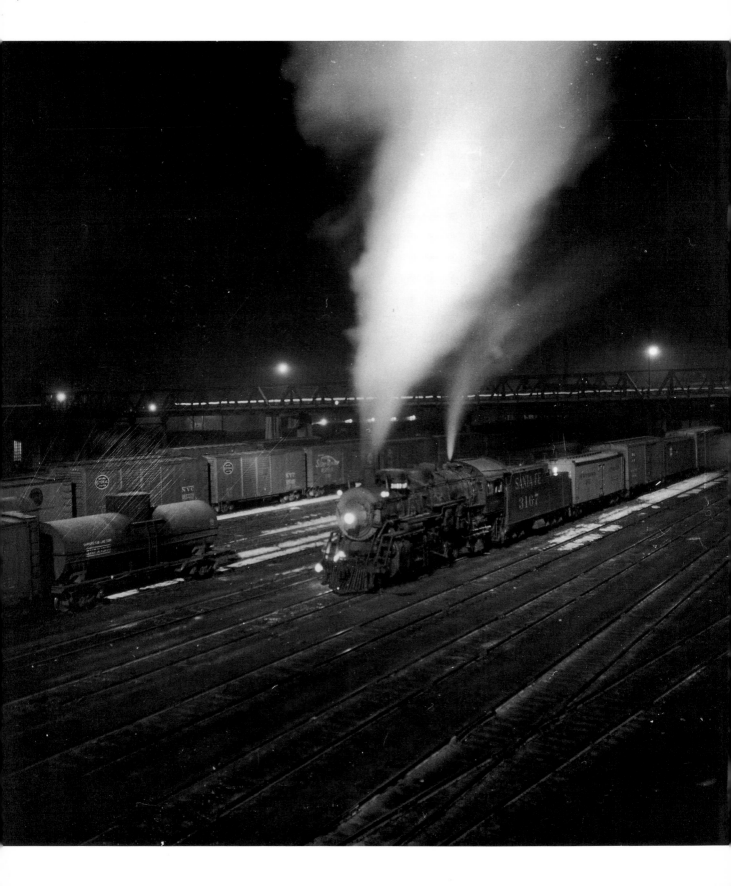

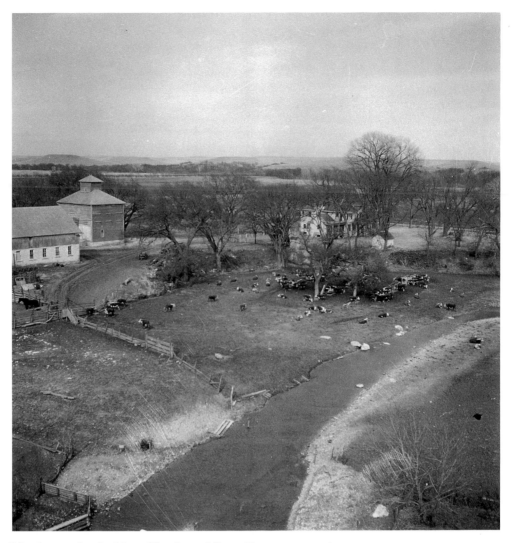

March 1943, An Atchison, Topeka and Santa Fe passenger train
between Emporia and Wellington passing through the Flint Hills district of Kansas.
This is a famous stock feeding area. LC-USW3-19823-E

March 1943, Argentine. Freight train about to leave the Atchison, Topeka and Santa Fe railroad
yard for the west coast. LC-USW3-19722-E

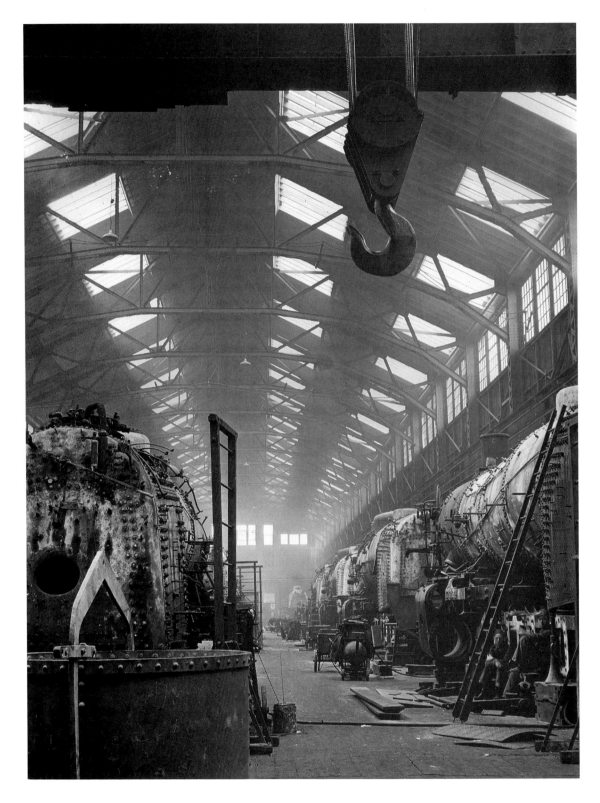

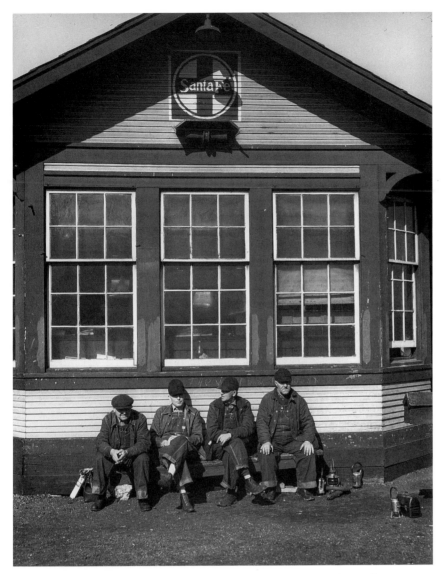

March 1943, Argentine. Atchison, Topeka and Santa Fe railroad switchmen waiting outside the yard office for the shift to change. They go on at 3:30 P.M. LC-USW3–19283-D

March 1943, Topeka. General view of part of the Atchison, Topeka and Santa Fe railroad locomotive shops during lunch period. LC-USW3–19305-D

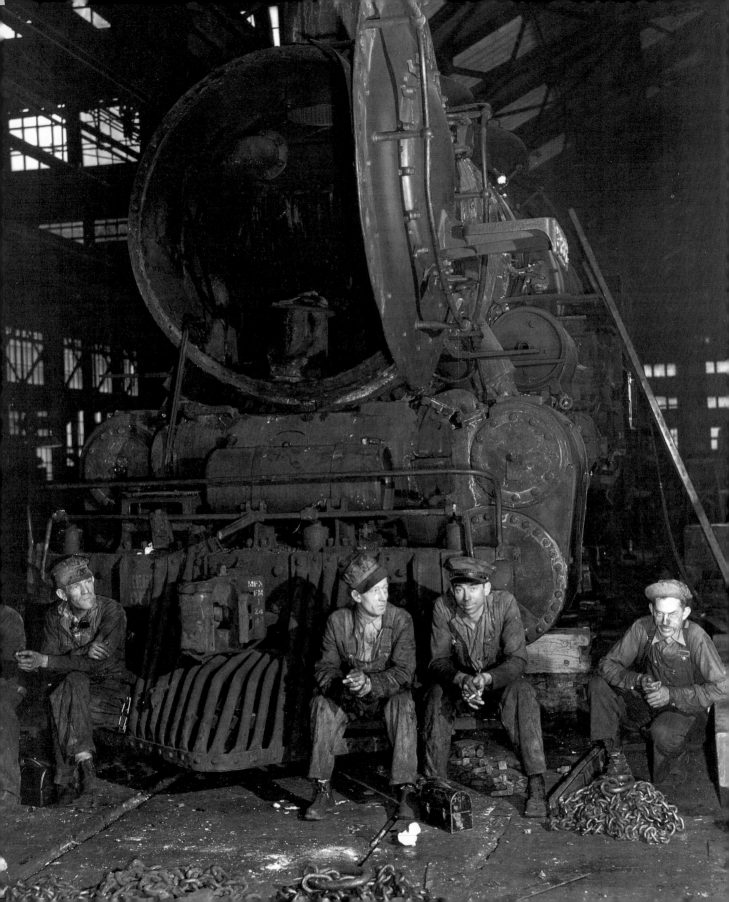

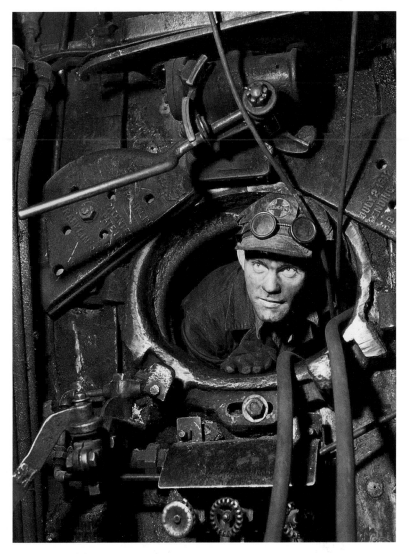

March 1943, Topeka. Homer Brandon, boilermaker's helper, crawling out of engine fire box door, in the Atchison, Topeka and Santa Fe railway locomotive shops. LC-USW3-19446-D

March 1943, Topeka. Workmen in the Atchison, Topeka and Santa Fe railroad locomotive shops resting during lunch period. LC-USW3-19307-D

March 1943, Topeka. One of the streets where many of the workers in the Atchison, Topeka and Santa Fe railroad locomotive shops live. LC-USW3–19290-D

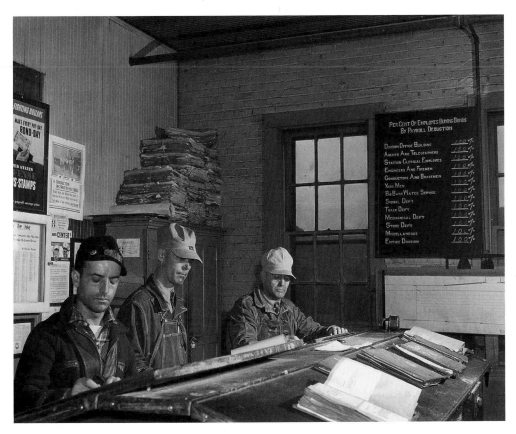

March 1943, Wellington.

Atchison, Topeka and Santa Fe engine crew checking in after a day's run.

Left to right: Brakeman W. I. Pace, Fireman Edward L. Hicks, and Engineer J. B. Aubuchon.

Note blackboard showing participation of railroad men in War Bond campaign.

LC-USW3–20106-D

March 1943, Topeka.

Two Mexican workers employed at the Atchison, Topeka and Santa Fe railroad locomotive shops.

LC-USW3-19309-D

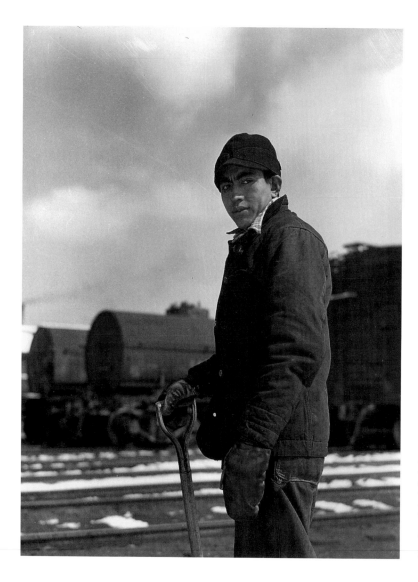

March 1943, Kansas City.
Peter Balandran, born in Chihuahua,
Mexico, a section worker at the
Atchison, Topeka and Santa Fe
railroad yard. LC-USW3-19363-D

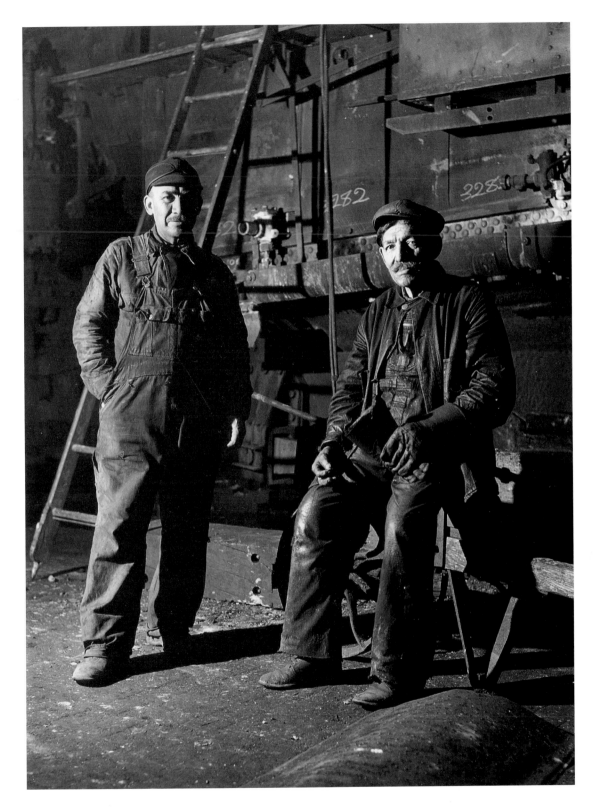

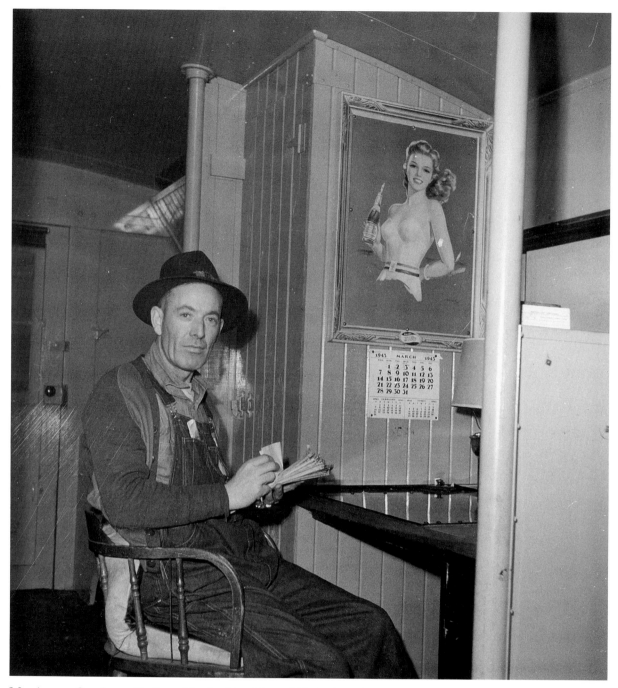

March 1943. Conductor G. Reynolds, checking his waybills in the caboose of the Atchison, Topeka and Santa Fe railroad between Argentine and Emporia. LC-USW3-19791-E

EDWIN AND LOUISE ROSSKAM

Edwin Rosskam (1903–1985), born in Munich to a German mother and an American father, lived in Germany during the First World War, emigrating to the United States in 1919. Educated as an artist in Philadelphia and Paris, where he studied with Man Ray, he taught himself photography. After he and Louise Rosenbaum married in 1936, they became the first husband-wife photographic team on the staff of the *Philadelphia Record.* Rosskam went to work for Roy Stryker in July 1939 when he was hired by the Farm Security Administration as a layout and photo-editing specialist. His first photographic assignment under Stryker did not come until 1943, when he and Louise joined the Standard Oil team as project photographers.

Louise Rosenbaum was born in Philadelphia in 1910 and studied biology at the University of Pennsylvania, working during summers at the Woods Hole (Massachusetts) Marine Biology laboratory. After graduating in 1933, she met Edwin in New York and became part of the artistic circles in which he moved. She recalls that she finally put her scientific training to work developing film and photographs in the darkroom. When she and Edwin joined the staff of the *Philadelphia Record,* the newspaper could not afford to send two people out on a story; instead of receiving a salary, she worked for "gas and oil money" as the writer for his photography and then gradually became a photographer herself.

The Rosskams spent several weeks of the summer of 1944 in the West photographing workers of the Carter Oil Company, an affiliate of the Standard Oil Company of New Jersey. Headquartered in Elk Basin, Wyoming, Carter Oil also had extensive oil fields in Montana and Kansas. The Rosskams were struck by the beauty of the region, and in a recent interview Louise remembered vividly the oil derricks growing out of the wheat fields near Cut Bank, Montana. They took more than fifty photographs near Susank, four of which are reproduced here.

In 1946, the Rosskams left Standard Oil at the invitation of Rexford G. Tugwell, who was by then governor of Puerto Rico. Put in charge of the Division of Community Education, they spent the next eight years creating a picture file of the island patterned after those of the FSA and the Office of War Information. Both Charles Rotkin and Jack Delano worked on that project under Edwin's direction. In 1953, with two children to raise, they returned to the mainland, settling in Roosevelt, New Jersey, where Louise has continued to live since Edwin's death.[*]

[*]Louise Rosskam, telephone interview with Constance B. Schulz, 24 March 1996; Plattner, *Roy Stryker,* 45.

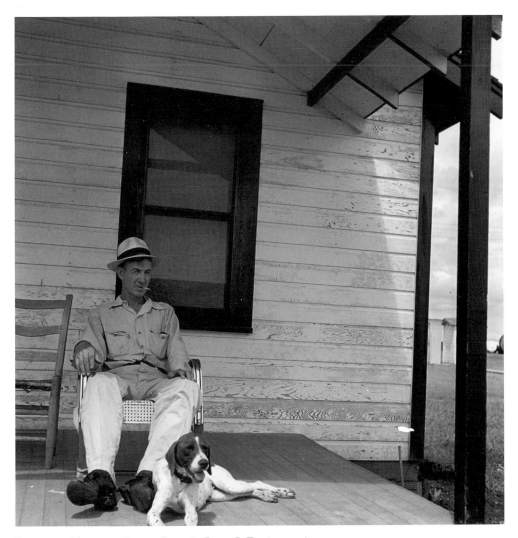

June 1944. Trapp pool, near Susank. Perry J. Farris, repairman,
on the porch of his house. SONJ-7510. Standard Oil (New Jersey) Collection,
University of Louisville Photographic Archives

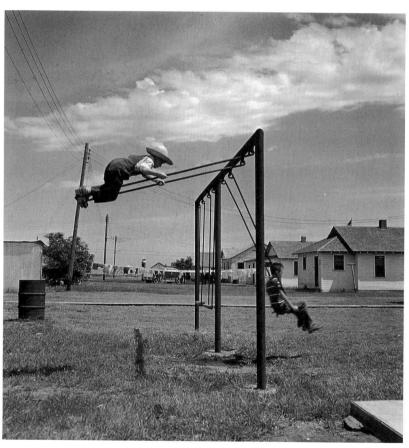

June 1944, Susank.

Children swinging. SONJ–7511. Standard Oil (New Jersey) Collection,
University of Louisville Photographic Archives

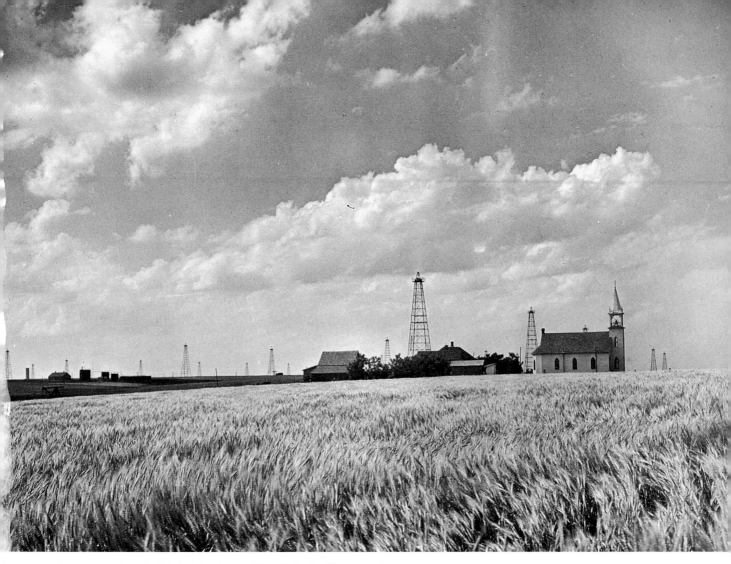

June 1944, Susank vicinity. Lutheran Church in the Trapp pool. LC-s89–7537

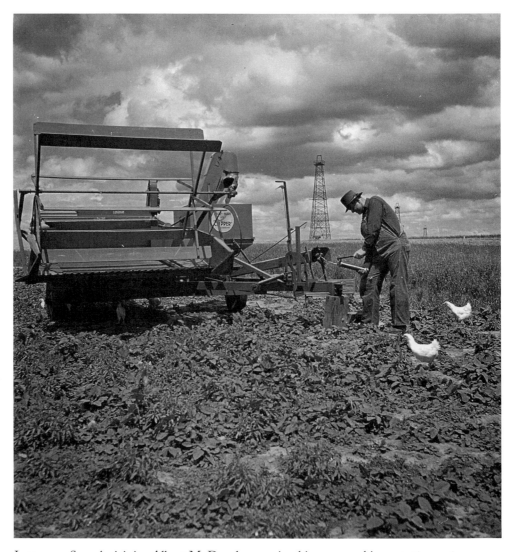

June 1944, Susank vicinity. Albert M. Dumler greasing his new combine. LC-S89-7518

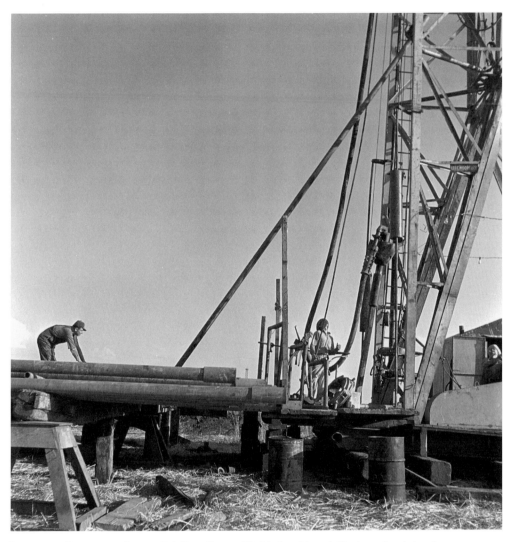

June 1944, Pratt area. Carter Oil Co., Coates Field. Stacking drill pipe after it has been pulled out of the hole and disconnected. SONJ–7554. Standard Oil (New Jersey) Collection, University of Louisville Photographic Collection

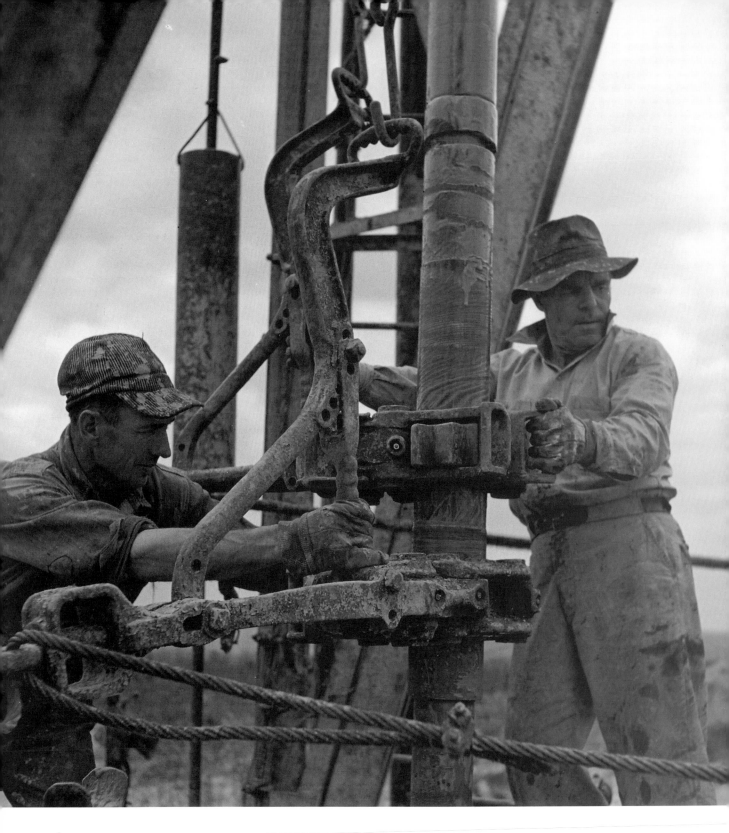

June 1944, Pratt area. Carter Oil Co., Coates Field. Unscrewing drill pipe. SONJ-7563. Standard
Oil (New Jersey) Collection, University of Louisville Photographic Archives

June 1944, Susank.
Shorty Zimmerman, roughneck who has four sons in the army.
SONJ-7577. Standard Oil (New Jersey) Collection, University of
Louisville Photographic Archives

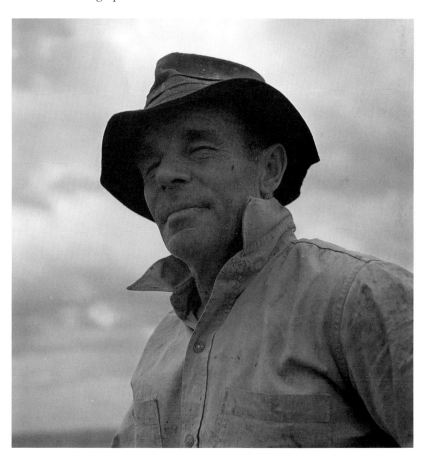

CHARLES ROTKIN

Charles Rotkin (b. 1916) was born and raised in New York. Early in 1941, Roy Stryker hired him as a photographer for the Farm Security Administration as a result of an introduction by his friends Edwin and Louise Rosskam. Drafted into the army at the beginning of the Second World War, Rotkin was assigned to duty in Puerto Rico; while there, he continued his photographic activities, setting up a darkroom for the use of fellow soldiers. Like Jack Delano and later the Rosskams, Rotkin fell in love with the island and its people. When the war ended, he remained there, joining the Rosskams in the Division of Community Education established by Governor Rexford G. Tugwell to create a documentary record of Puerto Rico modeled after the photographic files of the FSA and the Office of War Information. Rotkin experimented in Puerto Rico with small-plane low-altitude aerial photography, using a specially modified hand-held camera that enabled him to make clear and dramatic photographs at altitudes less than 1,000 feet above the ground.

It was this skill that Stryker sought when he hired Rotkin in November 1948 to document from the air the Standard Oil pipelines, oil fields, and refineries. His series of thirty aerial photographs taken between Kansas City, Missouri, and Lawrence, Kansas, during the summer of 1949 document the postwar return of the Kansas countryside to fertile fields and prosperous times.

After his SONJ contract ended in 1950, Rotkin became a student and teaching assistant of Berenice Abbott at the New School for Social Research in New York in 1951 and 1952. He continued his practice of aerial close-up photography in Europe and North America, publishing several photography books during the 1960s, and has taught at the International Center of Photography. Currently living in Peekskill, New York, he serves as a consultant to Microsoft Corporation's digital-photography program.[*]

[*]Charles Rotkin, telephone interview with Constance B. Schulz, 24 March 1996; Plattner, *Roy Stryker*, 112.

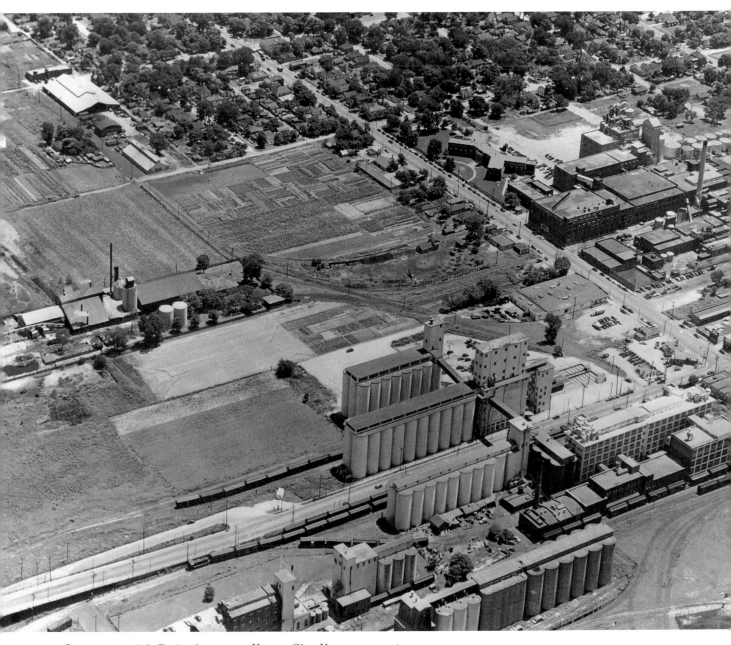

June 1949, aerial. Grain elevators at Kansas City, Kansas. SONJ–64494.

Standard Oil (New Jersey) Collection, University of Louisville Photographic Archives

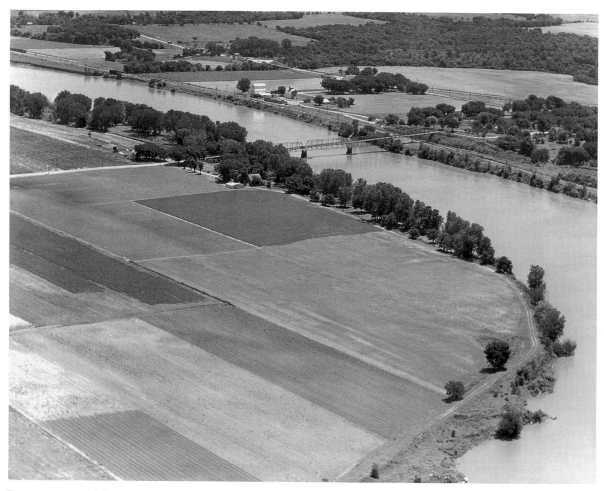

June 1949, aerial. The Kansas River and wheat country near the edge of Kansas City, Kansas. SONJ–64510. Standard Oil (New Jersey) Collection, University of Louisville Photographic Archives

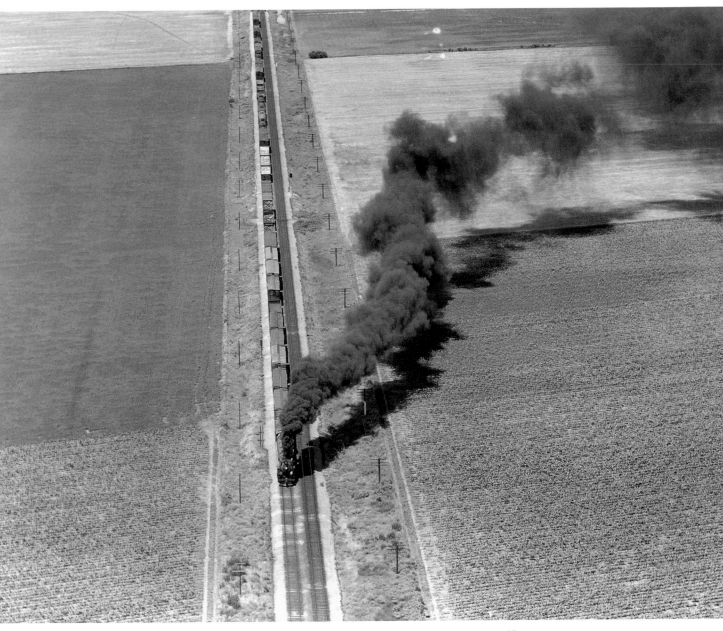

June 1949, aerial. Union Pacific freight train running through the wheat country east of Lawrence. SONJ–64481.

Standard Oil (New Jersey) Collection, University of Louisville Photographic Archives

ADDITIONAL READING

THE HISTORY

For an introduction to the entire region, an excellent study is James R. Shortridge, *The Middle West: Its Meaning in American Culture* (Lawrence: University Press of Kansas, 1989). A good place to begin investigating this era are the back issues of *Kansas History* (formerly *Kansas Historical Quarterly*); in addition to the articles cited in the notes, see vol. 15 (1992–1993) and vol. 17, no. 1 (Spring 1994), all on the Second World War. The war years are also discussed in Craig Miner, *Wichita, the Magic City* (Wichita: Wichita–Sedgwick County Historical Museum Association, 1988), pp. 183–98. See also William M. Tuttle, Jr., "Aid-to-the-Allies Short-of-War versus American Intervention, 1940: A Reappraisal of William Allen White's Leadership," *Journal of American History* 56 (March 1970): 840–58; and John Morton Blum, *V Was for Victory: Politics and Culture During World War II* (New York: Harcourt Brace Jovanovich, 1976).

State politics are well covered in Donald R. McCoy, *Landon of Kansas* (Lincoln: University of Nebraska Press, 1966); and Homer E. Socolofsky, *Arthur Capper: Publisher, Politican, and Philanthropist* (Lawrence: University Press of Kansas, 1962). The literature on the Roosevelt presidency is voluminous, but a reader might start with the four-volume biography by Kansas-born author Kenneth S. Davis (*FDR, The Beckoning of Destiny, 1882–1928* [New York: Putnam, 1972]; *FDR, The New York Years, 1928–1933* [New York: Random House, 1985]; *FDR, The New Deal Years, 1933–1937* [New York: Random House, 1986]; and *FDR, Into the Storm, 1937–1940* [New York: Random House, 1993]). Or turn to Paul Conkin, *The New Deal,* 2nd ed. (Arlington Heights, Ill.: AHM, 1975); or William Leuchtenberg, *Franklin Roosevelt and the New Deal, 1932–1940* (New York: Harper & Row, 1963).

On Kansas agriculture and the "dirty thirties," there are a number of useful accounts, including R. Douglas Hurt, *The Dust Bowl: An Agricultural and Social History* (Chicago: Nelson-Hall, 1984); Pamela Riney-Kehrberg, *Rooted in Dust: Surviving Drought and Depression in Southwestern Kansas* (Lawrence: University Press of Kansas, 1994); Lawrence Svobida, *Farming the Dust Bowl: A First-Hand Account from Kansas* (1940; Lawrence: University Press of Kansas, 1986); and Donald Worster, *Dust Bowl: The Southern Plains in the 1930s* (New York: Oxford University Press, 1979).

The economic distress of the period is ably discussed in Michael W. Schuyler, *The Dread of Plenty: Agricultural Relief Activities of the Federal Government in the Middle West, 1933–1939* (Manhattan, Kans.: Sunflower University Press, 1989); and it is nicely encapsulated in the radio script series, *Making Do and Doing Without: Kansas in the Great Depression*, rev. ed. (Lawrence: Division of Continuing Education and KANU, University of Kansas, 1990). For a more general portrait one should look at Robert S. McElvaine, *The Great Depression: America, 1929–1941* (New York: Times Books, 1984). For insight into a prominent minority group's experience, see Robert Oppenheimer's "Acculturation or Assimilation: Mexican Immigrants in Kansas, 1900 to World War II," *Western Historical Quarterly* 16 (October 1985): 429–48.

THE PHOTOGRAPHS

A good way to begin reading about the photographic heritage of the Farm Security Administration and the Office of War Information is the excellent study by Carl Fleischhauer and Beverly W. Brannan, *Documenting America, 1935–1943* (Berkeley: University of California Press, 1988), which contains a fine selection of the work of the photographers who worked for the History Section, as well as an informative description of the collection and how it came to be in the Library of Congress. A more general study by Sidney Baldwin, *Poverty and Politics: The Rise and Decline of the Farm Security Administration* (Chapel Hill: University of North Carolina Press, 1965), traces the political and administrative history of the agency. A similar approach to the history of the OWI can be found in Alan M. Winkler, *The Politics of Propaganda: The Office of War Information, 1942–1945* (New Haven: Yale University Press, 1978). Two well-illustrated books tell the story of the Standard Oil of New Jersey photographic project: Ulrich Keller, *The Highway as Habitat: A Roy Stryker Documentation, 1943–1955* (Santa Barbara, Calif.: University Art Museum, 1986); and Steven W. Plattner, *Roy Stryker: U.S.A., 1943–1950, The Standard Oil (New Jersey) Photography Project* (Austin: University of Texas Press, 1983). James Curtis, *Mind's Eye, Mind's Truth: FSA Photography Reconsidered* (Philadelphia: Temple University Press, 1989); Alan Trachtenberg, *Reading American Photographs: Images as History, Mathew Brady to Walker Evans* (New York: Hill and Wang, 1989); and James Guimond, *American Photography and the American Dream* (Chapel Hill: University of North Carolina Press, 1991), discuss the documentary-photographic movement in the United States, and the roles of Roy Stryker, the FSA/OWI projects, and the photographers, in that larger context.

Those interested in discovering more about Roy Stryker and some of the individual photographers will find the three biographies by F. Jack Hurley both well written and well illustrated: *Portrait of a Decade: Roy Stryker and the Development of Documentary Photography in the Thirties* (Baton Rouge: Louisiana State University Press, 1972); *Russell Lee, Photographer* (Dobbs Ferry, N.Y.: Morgan and Morgan, 1978); and *Marion Post Wolcott: A Photographic Journey* (Albuquerque: University of New Mexico Press, 1989). In the early 1970s, while many of the best known of the FSA/OWI photographers were still actively working, Hank O'Neal brought them together and interviewed them, and one of the results is a handsome book, *A Vision Shared: A Clasic Portrait of America and Its People, 1935–1943* (New York: St. Martin's Press, 1976), which has brief biographical sketches, photographic portraits of each taken during the 1930s or 1940s, and samples of their photography.

Although a number of photographic books have presented a cross section of the work of the FSA/OWI and the SONJ, almost none include any of the photographs taken in Kansas. The most important exception to this is a highly specialized study by James E. Valle, *The Iron Horse at War: The United States Government's Photodocumentary Project on American Railroading During the Second World War* (Berkeley, Calif.: Howell-North Books, 1977), with 272 photographs by Jack Delano, including a fine series from his trip through Kansas in 1943. Although it contains no images from their state, Kansans may enjoy the published selection that Nancy Wood helped Roy Stryker make from his personal collection of images: *In This Proud Land: America 1935–1943 as Seen in the FSA Photographs* (Greenwich, Conn.: New York Graphic Society, 1973).

This study of Kansas images in the FSA/OWI collections joins a growing tradition of state studies. While many of these have been of southern states (Alabama, Florida, Kentucky, Mississippi, South Carolina, and Virginia), Kansans might be particularly interested in looking at the images in John M. Zielinski, *Unknown Iowa: Farm Security Photographs, 1936–1941* (Kalona, Iowa: Photo-Art, 1977); I. Wilmer Counts, Jr., *A Photographic Legacy* (Bloomington: Indiana University Press, 1979), on Arkansas; Nancy Wood, *Heartland: New Mexico Photographs from the Farm Security Administration, 1935–1943* (Albuquerque: University of New Mexico Press, 1989); and Robert L. Reid, *Picturing Minnesota, 1936–1943* (St. Paul: Minnesota Historical Society Press, 1989).